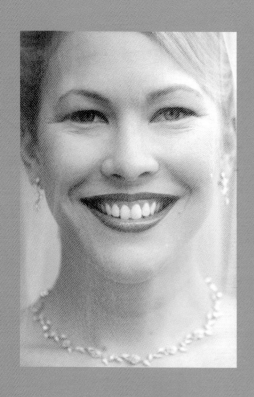

006

step-by-step / 006 /
digital wedding photography /

Paul F. Gero

ILEX

First published in the UK in

ILEX
The Old Candlemakers
West Street
Lewes
East Sussex BN7 2NZ

ILEX is an imprint of The Ilex Press Ltd
Visit us on the Web at:
www.ilex-press.com

Copyright © 2004 The Ilex Press Limited

This book was conceived by
ILEX, Cambridge, England

Publisher Alastair Campbell
Executive Publisher Sophie Collins
Creative Director Peter Bridgewater
Editor Adam Juniper
Design Manager Tony Seddon
Designer Kevin Knight
Artwork Administrator Joanna Clinch

Commissioning Editor Alan Buckingham
Development Art Director Graham Davis
Technical Art Editor Nicholas Rowland

British Library Cataloguing-in-Publication Data:
a catalogue record for this book is available
from the British Library

ISBN 1-904705-49-9

Printed and bound in China

For more information on this title:
www.sweduk.web-linked.com

step-by-step / 006 /
digital wedding photography /

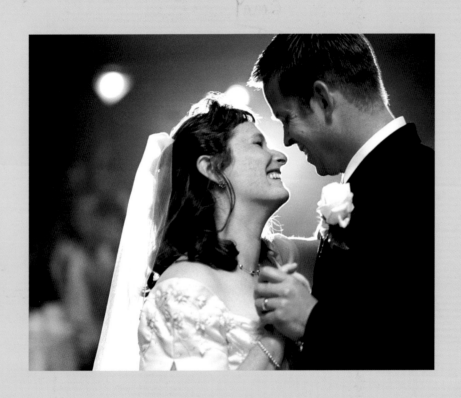

Contents

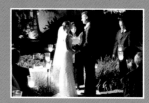

Introduction

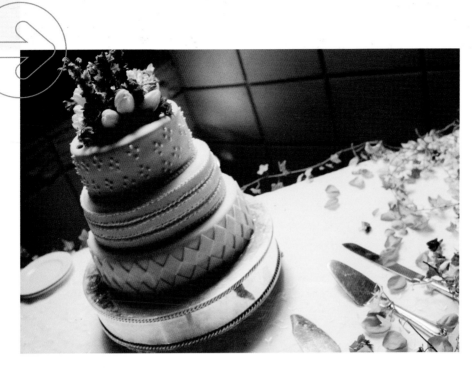

Details, such as
of the wedding
cake, are an integral
part of wedding
day coverage. The
lighting in the area
was already warm
and inviting – I
captured the image
with available light.

Digital cameras have revolutionized professional photography in a way not seen in decades. The change may be even more dramatic than the transition from glass plates to celluloid film (or vinyl records to compact discs, in the music industry).

The rapid adoption of digital cameras is now taking the consumer market by storm as well. Recently, and for the first time ever, digital camera sales have outpaced the sale of film cameras (first in revenues, now in units too). Digital cameras are showing up everywhere and are present at every wedding I photograph.

With this adoption, the general public becomes more and more comfortable with digital, and less concerned when professional photographers use the technology. Indeed, as the children of today grow up, digital will be all they know. Any notion of film will be a foreign concept and something they might only read about, much like 8mm is to Generation-X.

Camera manufacturers are aware of this trend and are relishing the returns. Research and development and its subsequent advances (plus a tightening economy) have made the use of digital more accepted than many professionals would have anticipated. No longer is the digital camera the preferred

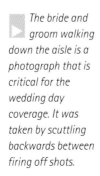

The bride and
groom walking
down the aisle is a
photograph that is
critical for the
wedding day
coverage. It was
taken by scuttling
backwards between
firing off shots.

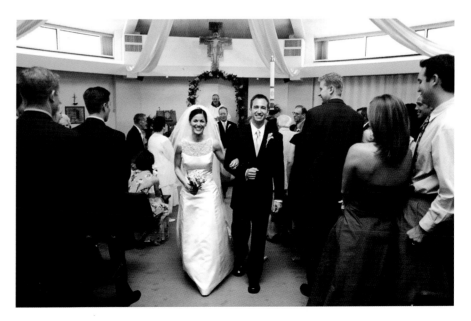

When digital photography first arrived, it appealed mainly to newspapers and consumers, both interested in instant results. However the appetite for speed has now influenced people's decision-making in every area of photography.

tool for just newspaper and magazine photojournalists. Digital is becoming the tool of choice in the wedding and portrait world as well.

Still, there are many photographers who resist digital capture for many reasons, or simply prefer using film. Those photographers can still enjoy the benefits of digital technology. With the advent of high quality (such as the Fuji Frontier) and reasonably priced film scans, these photographers can enjoy the workflow benefits of their digital capture colleagues. In this book, we shall look at how to use digital technology (either from digital capture or from scans of film) to improve your images and give value to your wedding clients.

When any new technology emerges, the learning curve can appear steep and insurmountable. In this book I endeavour to make the path less daunting. Wedding photography was once a rather closed, perhaps even quaint field. Now with lightning-fast digital tools everyone is welcome to the party. It's my hope that this book will help you begin to embrace that, and make the most of your clients', or your friends', big day.

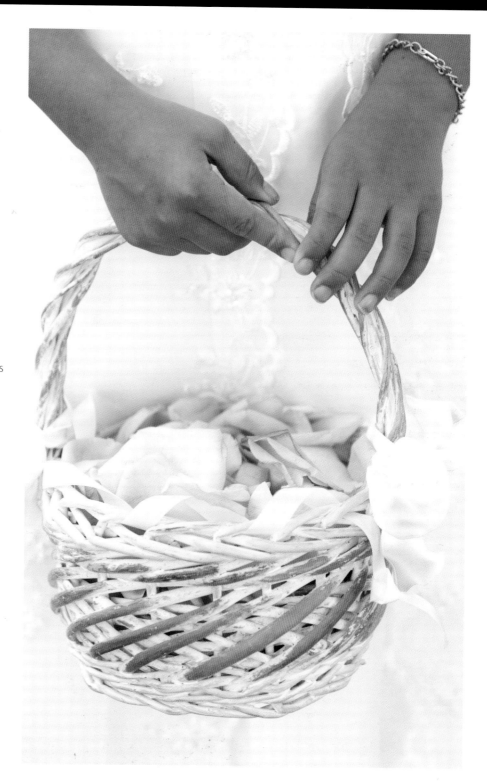

Look for details throughout the day (here the bridesmaid holds a basket before the ceremony). This photo was taken in the shade with available light.

Introduction

Look out for portrait chances that show the scene. There has been a trend for tightly framed shots of the subject, but they lack a sense of context. This image could be used as a full-bleed panoramic image in the modern album.

'Getting ready' photographs are some of my favourites, and give me a chance to capture natural moments of the bride's transformation. They also help people become comfortable with my presence at the event.

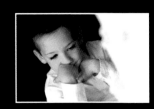

You'll need to master two different styles of portraits to offer a complete record of a wedding. There are the classic poses of the bride and groom at one end of the scale, and intimate photojournalistic work at the other.

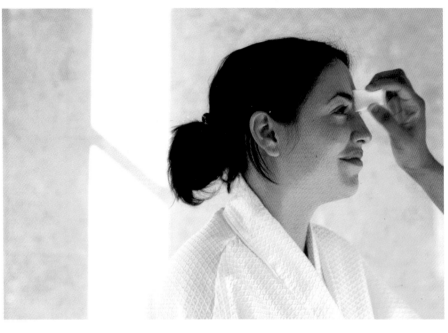

A certain amount of portraiture is required of all wedding photographers, even documentary photographers. Keep them fun, easy, and natural for low stress on the bride and you!

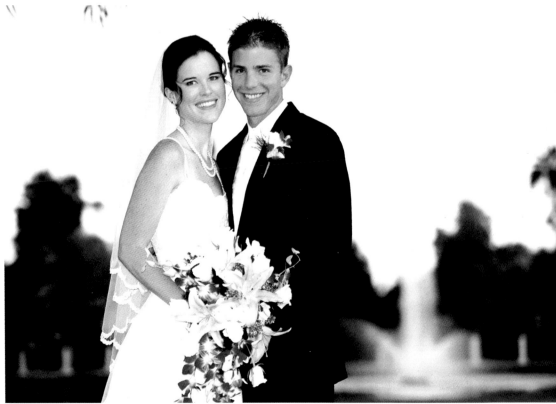

Introduction

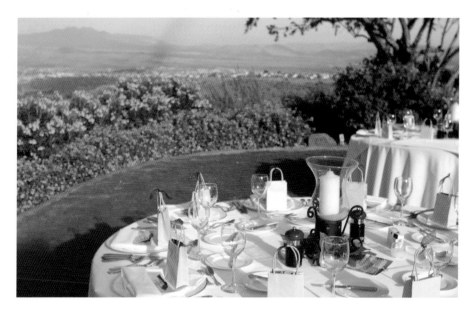

Try to get a photograph of the place settings before the reception begins. Here, late afternoon light and an amazing vista added to the scene.

This expressive shot was illuminated with the diffused light of an off-camera flash, held by an assistant.

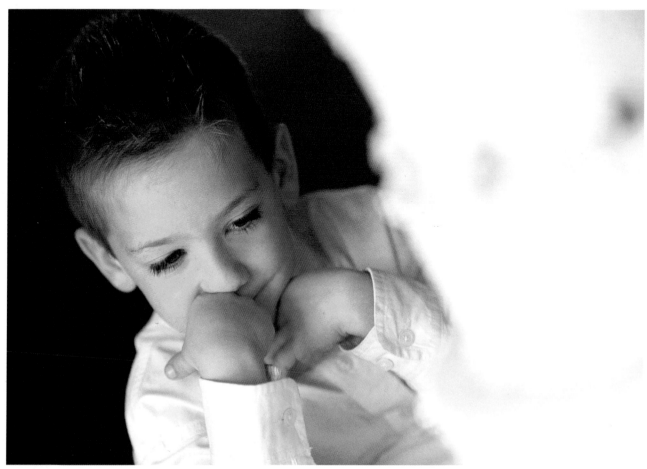

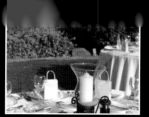

In many ways, a wedding is as much about the details as it is the guests. Each little touch will invariably have been discussed, fought over, and decided upon by whoever planned the wedding, and they'll want a reminder.

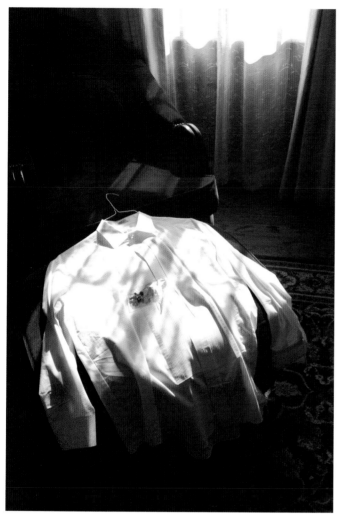

The pattern of the light coming through the window onto the groom's shirt is a classic opportunist's shot. Shooting digitally allowed settings to be tweaked during shooting, to optimize the exposure, in this case by setting a very subtle bounce strobe, which helped fill in the shadows.

Shooting digitally made it possible to check the effect of the flash that was used to light this photograph of the cake. The LCD allowed me to check the quality of the bounce light and tweak my placement as I worked.

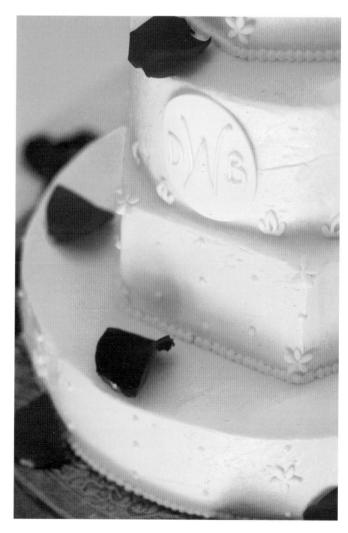

1 Your digital camera

The first thing to know about digital cameras is that they are really computers that happen to take photographs. OK, they look like your old 35mm film camera, but within them is the beating heart of a computer. Given this, photographers have a range of new opportunities, and a few new problems, on their plate. In this chapter we will take a look at these issues, and how they can be used to get the perfect wedding shot every time.

Anatomy of the camera

Digital cameras come in all shapes and sizes, from minute lenses in mobile phones, through compacts like this Canon to the bulky but feature-packed SLR.

At first glance your new digital camera will look suspiciously like previous film cameras. With the exception of the size of the digital chip (usually smaller than the 24 x 36mm size of 35mm film) you will feel right at home as you step into digital from the 35mm film camera world.

An SLR camera is the most flexible option available to you, since you can change the lens. The only price of this, apart from the financial one, is the weight of your camera bag.

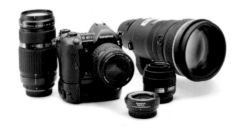

CMOS OR CCD

The capture chip of most digital cameras is less than the size of a full-frame piece of 35mm film (with rare exceptions). These chips are light-sensitive devices that capture the scene you are recording. Because the chip is smaller than 35mm, your effective depth of field will be greater than film.

LENS/ZOOM

For high-quality digital wedding photography, the better glass you have, the better the quality of the image. Fixed focal length lenses are usually sharper than zoom lenses, but that difference is shrinking. Premium-grade zoom lenses, such as Canon's L series or Nikon's ED series, are optical marvels and perform close to their fixed focal counterparts. Lenses are usually magnified because of the digital multiplier effect (anywhere from 1.3 to 1.6x). Therefore a 16mm lens on a camera with a 1.3 magnification would be approximately a 21mm lens; on a 1.6 magnification camera it would be a 25.6mm lens.

AUTOFOCUS/MANUAL FOCUS

Most prosumer or professional grade digital cameras are autofocus cameras which allow you to override and focus manually if you choose. The quality of autofocus is good, and, with the availability of multiple focus points and low light focus aided by an infrared beam, it is incredibly precise.

LCD MONITOR OR VIEWFINDER

Digital cameras allow you to view the image through the eyepiece viewfinder. Amateur cameras will often allow you to view the image being shot in real time through the LCD monitor too (sometimes they do not even have a traditional eyepiece). Most prosumer and professional bodies, however, will only allow you to review the images after capture. You want to be able to view a histogram on the panel as well as being able to zoom in on the display to check focus.

STORAGE

Most cameras utilize Compact Flash (CF) card technology, though there are others. Your choice as to size of card will depend on the size of the chip and the file sizes generated and the type of format you prefer to capture the image. Shooting in RAW format will demand more storage than shooting JPEG.

CAPTURE MODES

RAW gives you the most options and flexibility, while JPEG creates smaller files. RAW will allow you to correct images with proprietary software and work in the 16-bit space (this is particularly useful for commercial shooters going to offset press, but less of a concern for wedding photographers outputting to photo printers). JPEGs are usually faster to write to most cards, too, since less data actually needs to be written to the card.

In reality, your choice of camera is usually limited by your budget, but there are other key considerations. Size is an important trade-off, with very small cameras looking tempting, but usually sacrificing flexibility and quality.

SHUTTER

Most prosumer and pro digitals have shutters like their film counterparts. Most of these cameras will have a Bulb setting that will allow you to take long exposures. CCD chips tend to develop noise during long exposures whereas CMOS chips work much better.

APERTURE

As with film cameras, this regulates the amount of light to hit the CCD or CMOS sensor. Lower numbers mean smaller amounts of light pass through the lens; larger numbers mean more light passes through the lens. A small aperture also means more depth of field or more items in focus from the foreground to the background. A large aperture or opening means that there is a shorter range of focus, though that limited depth of field is extended if you use a telephoto lens. Also, with chips which are smaller than 35mm, film lenses will give you more depth of field than they would if you were using film.

EXPOSURE CONTROL

More and more prosumer and pro cameras have all the modes that are found on high-quality film cameras, including aperture priority, shutter priority, manual, and program exposure. Less professional cameras often have pre-sets for a variety of situations, including portraits, sports, and scenic views.

EXPOSURE METERING

Most prosumer and pro cameras include evaluative or matrix metering (the scene is parsed into sections and information about light hitting the scene is transmitted to the camera). This is usually the most accurate, but can sometimes be fooled in very brightly lit or very dark situations. Other modes include a centre-weighted averaging, and spot meter parts.

EXPOSURE RANGE

Usually the cameras will offer settings from ISO 100 through 1600 or beyond in some cameras. The higher the ISO, the higher the amount of digital noise (like grain), the lower the ISO, the higher the quality of the file.

WHITE BALANCE

Most cameras have a variety of settings to correspond with the light in which you are shooting. Auto White Balance reads the scene information and transfers that to the camera, while a pre-set keeps the light the same. You can also create a custom white balance in the scene you are shooting, which is useful for an odd light source or to eliminate a colour cast (as you might find when shooting under fluorescent light).

Somewhere between the compact and the SLR is a prosumer range of high-quality cameras which nonetheless have built-in lenses and perhaps more of a consumer style.

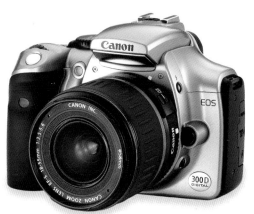

Canon's Digital Rebel is targeted at the prosumer market but it is actually a real SLR, giving its owners access to Canon's huge range of lenses from a comparatively low-cost body.

FLASH

Many prosumer digital cameras will include a pop-up flash that can be a lifesaver at times. Be careful if using this flash with a wide-angle lens as the lens hood may cast a shadow onto the foreground. Most of these same cameras have a hot-shoe which will allow you to place a supplemental flash unit on board, which is advisable for most wedding photography.

BATTERY

Some cameras work with proprietary batteries and chargers, others use AA batteries and lithium batteries. Battery duration is dependent on outside temperature, how much you use the LCD panel, and even the type of chip (CMOS sensors use less power).

IMAGE RESOLUTION/FILE SIZE

Cameras come in a variety of designations usually based on the number of pixels on the chip (usually in millions). Generally speaking, the higher the pixel count, the better the file quality, and the larger you can print it. Pro cameras may have the same megapixel rating as consumer cameras, but the pro camera will typically produce better results.

The lens

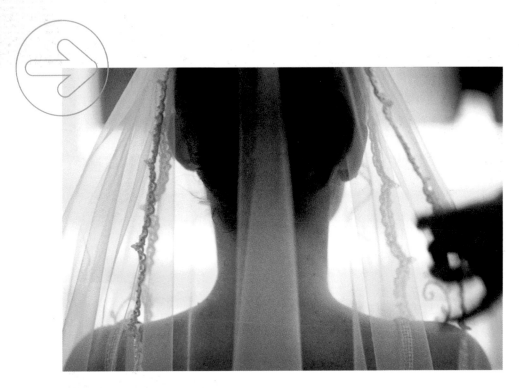

Zoom lenses have evolved to the point at which they are the preferred lenses of many wedding photographers. The ability to crop in-camera is an advantage over a fixed focal length lens.

Manufacturers have dramatically improved the performance of these lenses and now they rival the performance of fixed focal length lenses.

Wide-angle zoom lenses in the range of 16-35mm are popular with photographers because they become more moderate when placed on digital cameras (because of the smaller chip and magnification caused by that smaller chip).

These lenses get better with each generation. They are now sharper at maximum aperture, and focus closer than ever before.

Wide-angle lenses are useful if you want maximum depth of field and to give a sense of place. Be careful when using them though. If the subject is too close, it can look distorted. Even though it is easier to turn the ring, I prefer to set the focal length and then only zoom if it is really necessary. It forces a discipline of zooming with my feet and

prevents me from getting too wide with the lens, which is no bad thing.

Telephoto zoom lenses can be useful during the ceremony, and during the reception. These lenses now offer built-in image stabilization (like a video camera); this allows you to handhold the camera at a slower shutter speed than ever before. They are great for portraits of the couple especially close to maximum aperture (since it will drop the background out of focus).

It's a good idea to use lenses longer than 50mm for tight portraits. Using a lens shorter than that can create distortion. By using a short telephoto lens, or the short end of a telephoto zoom, you get a compressed perspective, and that will also allow for more blurred backgrounds, especially if you shoot close to maximum aperture.

Some photographers will work with an 85mm f1.2 or f1.4 lens at maximum aperture to create an incredibly dramatic photograph with razor-thin depth of field.

In this photograph, I used a 135mm telephoto lens, close to its maximum aperture, in order to create a very narrow range of focus.

Shot with a moderate wide-angle lens (35mm), at a wide aperture, I was able to show the groom hugging a friend with his wife visible in the background. The wider angle gives a broader feel of the environment; a telephoto lens would have isolated the subject and eliminated the context.

TIP With compact zoom cameras, be mindful of the motor noise in quiet moments.

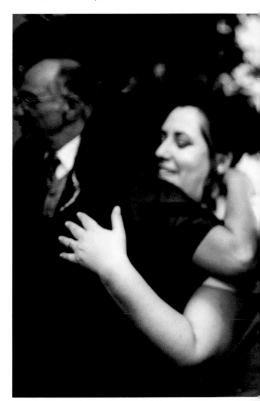

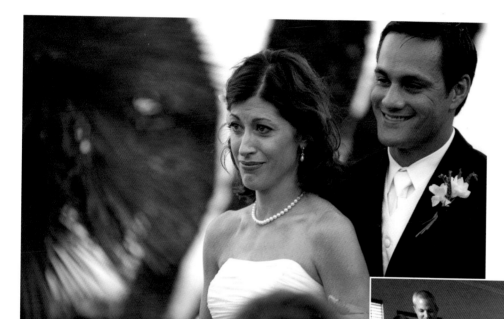

A telephoto zoom lens allowed me to home in on the bride and groom's reactions during the toasts. Soft, diffused late-afternoon light near sunset provided a wonderful feel.

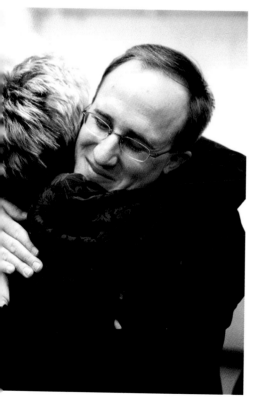

A short telephoto lens was used here to isolate this table arrangement, which was lit only by the light from the candle and the very low ambient room light.

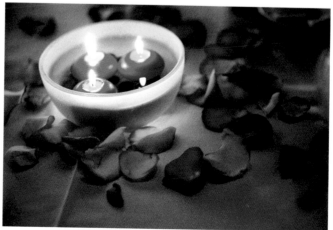

A wide-angle zoom lens (16 – 35mm) was used to show the groom (left) and the ushers getting ready in a hotel room. Shot digitally and captured in colour, it was converted to black and white in post-production.

Focusing

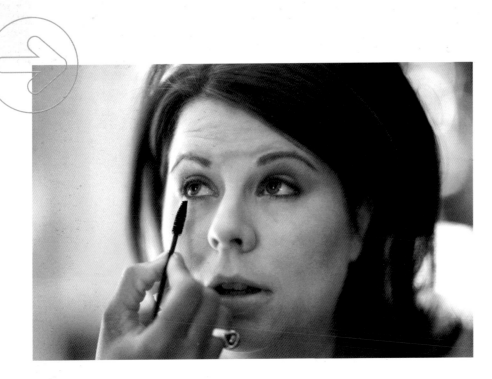

As the bride prepares and has her make-up applied, a short telephoto lens at close to maximum aperture demands attention to focus, in this case, the bride's eyes.

Autofocus cameras have dominated the 35mm camera market since the late 1980s/early 1990s and have begun to make inroads in the medium-format world. These lenses are now amazingly accurate, and virtually silent. Many a photographer's career has been extended because the quality of today's autofocus optics has aided failing or weakening eyesight.

Autofocus allows high-quality tracking of fast-moving events like motor racing and sporting events. It is rare to see anything other than autofocus camera/lens combinations on the sidelines at most major sporting events, they have so totally dominated the market.

While the action at a wedding is often quick, it is usually relatively pedestrian when compared to the action of a major sporting or news event. Nevertheless, the wedding photographer can benefit greatly from the advances in autofocus technology.

Autofocus is especially handy when using fixed telephoto or telephoto zoom lenses. Precision in focus is critical because these lenses are often used at their maximum aperture. The beauty of that is that the image captured at maximum aperture has a certain look because of the reduced depth of field.

Shooting hand-held with wide-angle lenses requires a precision of focus as well. Critical focus is dependent on a critical placement of the focus sensor. These sensors seek contrast and so should you. I look for maximum sharpness in the eyes, so focus on the area where the eyelid and eye meet. Locking in that focus, I then recompose. In time you'll get very fast at the focus, lock, and recompose action. Soon it will be second nature.

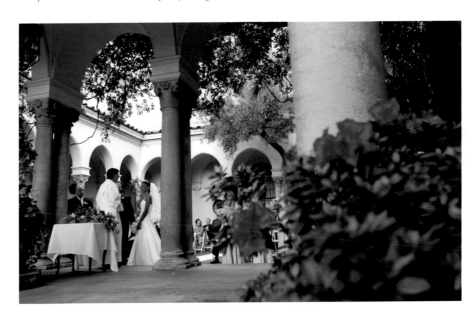

A wide-angle view of the ceremony included some colourful flowers, out of focus, in the foreground.

Concentrating the viewer's attention on a subject can be achieved using focusing techniques. As a photographer you're acting as editor, highlighting the area of most interest, so keep your audience in mind when making your selection.

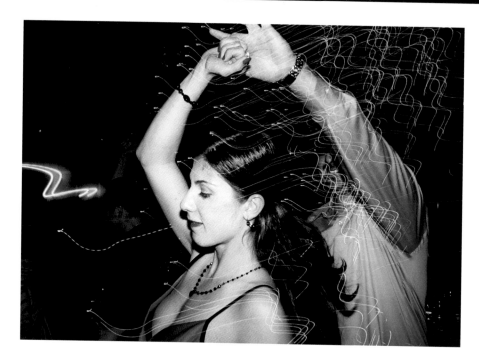

Using hyper-focal distance (zone focusing) I was able to shoot with a moderate wide-angle lens, set the focus for 3.5 feet to 10 feet (with flash), and literally point the camera in the direction of my subjects.

Another way to focus, particularly with wide-angle lenses, is to use the principle called hyper-focal distance. By focusing in this manner, you set the lens for a certain distance and by virtue of depth of field, areas in front and behind the direct point of focus will be sharp. This could come in handy at a dark reception when you want to select a zone of focus from three feet to six feet, as an example. It might be tricky to do this on some lenses that lack the depth of field scale, so consult your manual. It is very difficult with telephoto lenses because of their much smaller angle of view, so would not be advised.

Most of the work I do at a wedding is at maximum aperture, or close to it, so critical focus is demanded. The rare times I go beyond f8 are when I am in bright sunshine, or shooting a scene-setter with a wide-angle lens and maximum depth of field is called for.

By changing the focus subject to the foreground and the flowers, and using a wide-angle lens at close to maximum aperture, I was able to give a hint of the ceremony, and show the bright flowers that were in full bloom.

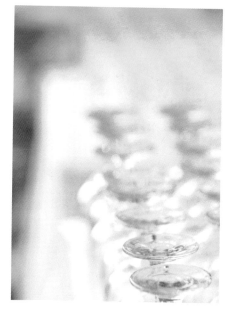

A very narrow depth of field, large aperture, and a telephoto zoom lens combined to create this striking graphic photograph of the many wine glasses, cleaned and lined up for the reception.

Getting the right exposure

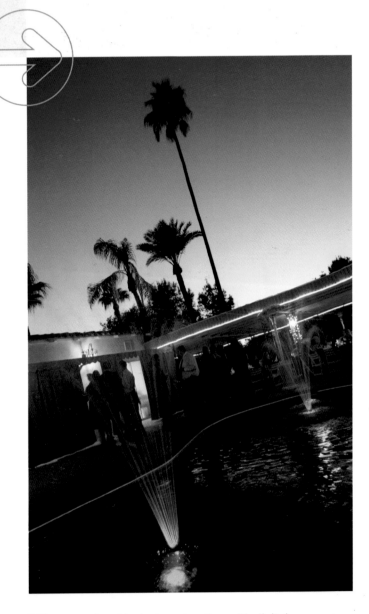

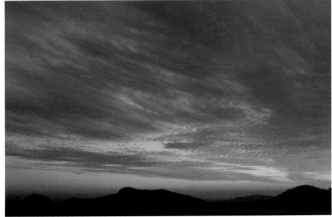

I used matrix metering to expose for this Arizona sunset and was able to check the histogram as I shot. I was looking for the peak colour while still seeing detail in the hills. Bracketing in 1/3-stop increments was useful in this situation.

Using a tripod I was able to shoot a long exposure and balance the light from the fountain with the light by the guests and the sky. Checking the histogram helps gauge your exposure in these tricky lighting situations.

Exposure is critical when shooting with digital cameras. As I write this, the best digital cameras still have the dynamic range of slide or transparency film (at capture). Using RAW software can even give you a range of + or – 2 stops (they say) on both underexposure/overexposure, but the best thing to do is to nail the exposure right away. These cameras are not like shooting colour negative film with 11 stops of exposure latitude so you have to be aware of exposure at all times.

This will get better as effort is spent on the research and development of digital cameras.

There are two ways to determine exposure with digital cameras: the on-board, in-camera meter, or an external, hand-held meter.

Matrix metering has become the mainstay when it comes to exposures (evaluative meter in the Canon world). Most pro or semi-pro cameras also allow for centre-weighted and/or spot metering as well.

For most of my work, I use evaluative/matrix metering. In those rare circumstances where I might need to alter that, I would opt for a spot meter reading. The beauty of digital, though, is that you can shoot, check the histogram, and then alter the camera settings to optimize the exposure.

One tricky situation is back-lighting. Digital cameras still have a fairly narrow dynamic range (though always improving) and because of that, the meter can be fooled. I have also discovered that digital cameras seem to favour slight underexposure so that highlight information is not lost.

I set my camera to the centre focus point. It is generally considered to have the best predictive autofocus sensitivity; I also have the exposure metered from this point. The value can be locked in (if in Auto or Program) by depressing the shutter release halfway.

If in doubt, shoot a test exposure of a scene that seems difficult to judge, and then analyse that exposure using the histogram.

Consider buying an external incident/flash meter. This is always a great backup and can be useful when using your flash units manually. While not as fast as using the in-camera metering, having accurate exposures saves time on the back end.

Bracketing or photographing the same scene with slightly different exposure is possible but difficult in the fast-paced world of wedding photography. You might be able to do this while shooting an overall view at the church or reception site.

Dancers at a reception are slightly blurred in this available light shot in low light. Metering to retain information on the dancers, the highlights are overexposed slightly which works here.

Shooting into the setting sun can be tricky (not to mention not really recommended). Meter with matrix and expose for the middle area, away from the sun.

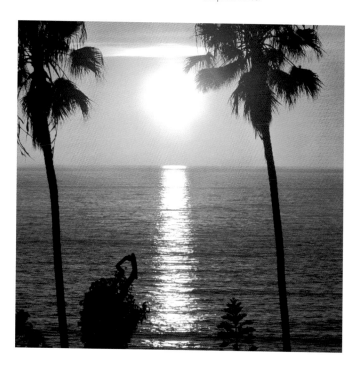

Bracketing

These two photographs illustrate the difference that 1/3 of a stop can make in digital imaging. I bracketed so I could control the light from the sun (lower left). In print, the dark photograph, top, would have to be manipulated to open up shadow information; in the bottom one, though, it will be impossible to bring detail back into the highlight area – it is overexposed beyond saving.

Low light exposure

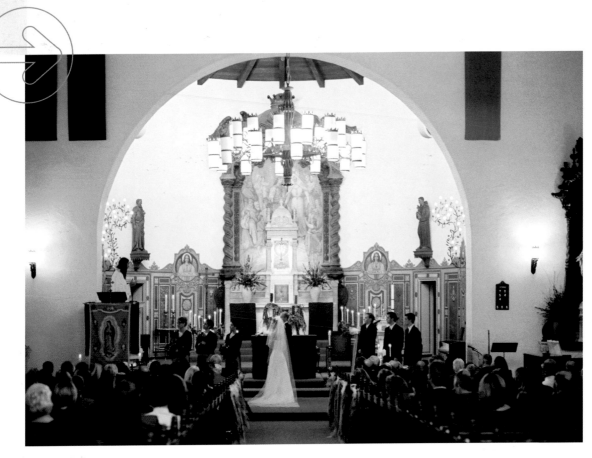

A large aperture lens and high ISO allowed me to capture this with no supplemental lighting. Adding flash will draw attention to you while working. If you must use it, use it discreetly.

Working in low light can be exhilarating – and scary. With practice you will learn when it is possible to work in low light, and how to make it work. During the ceremony, the light is low, and you have to work with the available light because you may not be allowed to use strobe. If you are in the back of the church this means using a telephoto lens, which, in turn, means you need a higher shutter speed. With a shutter speed slower than 800 ISO you have to be very aware of camera shake caused by the mirror bounce on exposure.

Movement can create an exciting, even funky, effect, but it can also kill a good frame. Be aware of what the shutter speed's effect on the photograph is. You will be able to check the back of the camera to see.

Use the fastest lenses possible to ensure enough light hits the sensor. Premium-grade, fixed focal length lenses often allow you to shoot at f1.4 apertures, which is significantly faster than f2.8, and especially f4. The viewfinder will be brighter, and that aids focusing. With a faster aperture you can use a slower ISO rating, which helps with quality.

With telephoto lenses, camera shake is magnified because the lens' angle of view is narrow, and any movement is more apparent. There are image-stabilization devices in some lenses that work to keep the lens steady, even at slow shutter speeds. As you raise the ISO to gain a higher shutter speed, be aware that more noise will be evident in the image (though this is being improved upon constantly).

A monopod is useful to hold the lens steady, or you can lean against a church column or pew. Take a deep breath before releasing the shutter and gently trip the shutter as a target shooter would fire a gun. Try to relax.

In fast-moving situations a higher ISO might be a necessity. Balance the need to stop the action with the need to optimize image quality. I think it is better to have more grain or noise in the image than to risk the chance of a blurry shot by virtue of a slower shutter speed. I tend to feel that the moment is critical, and the aesthetic of the image is secondary (within reason). That comes down to a philosophical decision based on the goals I am trying to achieve with my work.

TIP A camera set at a high ISO setting may nevertheless pick up a lot of grain.

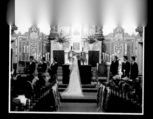
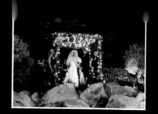

Low light is something that you are almost certain to come across at a wedding, where the reception can stretch well into the night. You'll need to be prepared both to use flash subtly, and to take long-exposure shots.

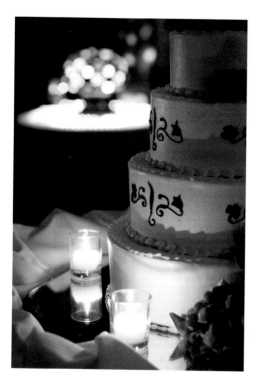

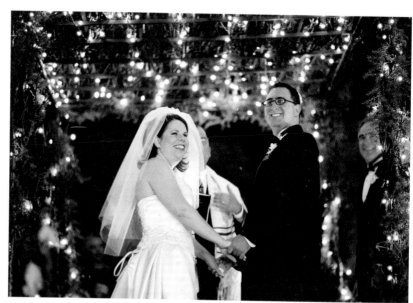

This wedding cake was lit by the candles in front, and the multi-coloured light in the background added an interesting element. A high ISO and a fast aperture prime lens was used here.

This photograph is from the same service as below; this was shot with a fast telephoto lens (85 f1.2). This allowed me to capture the moment without imposing flash on the scene.

The rocks were lit by soft light behind me in this available light photograph. A high-speed ISO was useful, as was a fast, wide-angle lens.

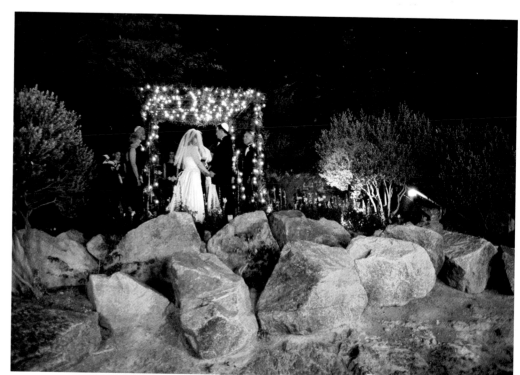

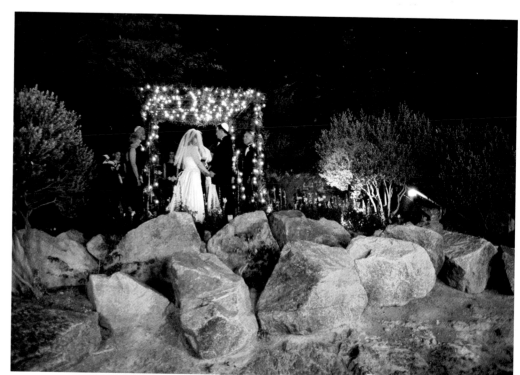

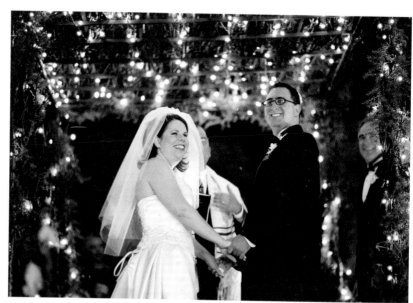

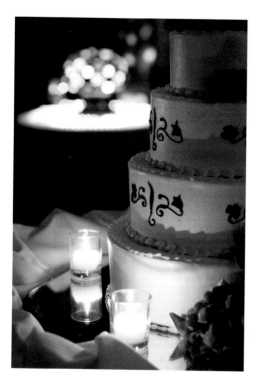

Low light exposure

Artificial light and colour temperature

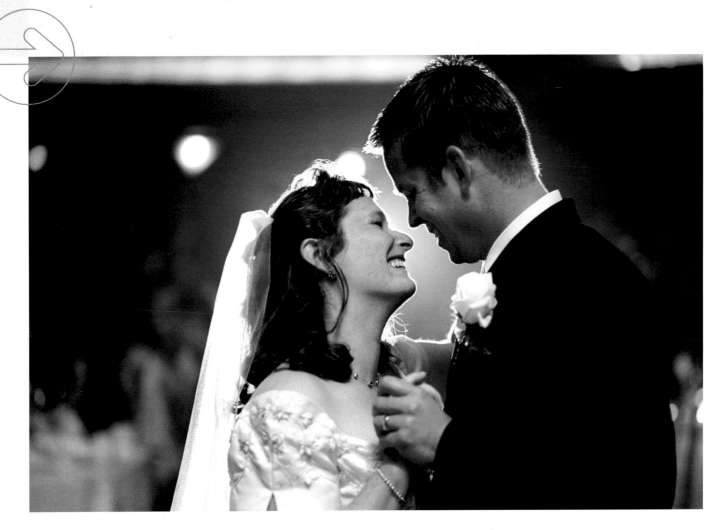

Light sources have a colour temperature that affects your images. Incandescent or tungsten lighting has a red/orange glow, which is quite inviting and warm, but can be too much. Fluorescents, on the other hand, give off an unappealing green. You can use your camera pre-sets to compensate, and they will do a fairly good job of eliminating the colour cast, though a custom white balance is a better bet to neutralize colour shift.

Many cameras have pre-set colour balances for daylight, shade, tungsten, etc. Experiment with these colour settings and you might find that you prefer one over the other. Many photographers prefer a shade setting in daylight rather than the daylight setting because it is slightly warmer. If you shoot in RAW format you will be able to change the colour temperature after capture, in post-production. Some photographers may prefer to shoot in auto white balance and then tweak their final RAW images on the computer after the fact.

In controlled situations, it is advisable to set a custom white balance. Every pro, or semi-pro, digital camera will have this feature. This renders lighting and it overcomes any colour casts in-camera.

Another way to work is to use your on-camera flash in a tungsten environment. With a slow exposure, the strobe will fill in the foreground area nicely while the background will have the warm glow of tungsten.

Some cameras will allow you to adjust the colour temperature (measured in degrees Kelvin) as a function of the camera. In a low light, tungsten environment, a setting of 2,800 degrees Kelvin might be a good way to capture available light without the colour being too orange/red. Conversely, by raising the colour temperature or using the tungsten lighting pre-set in a daylight environment, one can create a very blue look. Ultimately, the safest way to work is shooting RAW, auto white balance, and then using your post-production software to tweak your final output.

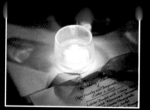
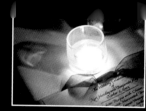

Wedding photography can involve working both indoors and out, not to mention being at more than one venue, all in one day. Being conscious of the lighting conditions is essential, especially if you want to save time in editing.

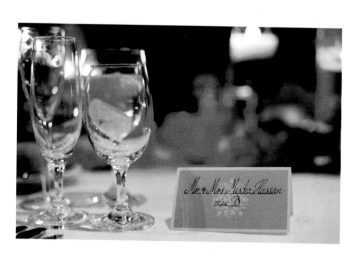

The warm light on the couple is from bounce flash off a warm-coloured ceiling; the blue light is from another photographer's flash.

The beauty of digital is the ability to change colour balance on the fly. Here's the colour temperature with the camera's white balance set to auto.

These wine-glass photographs illustrate the effect of the flash. In this image, the flash was not used. Compare it to the shot beneath.

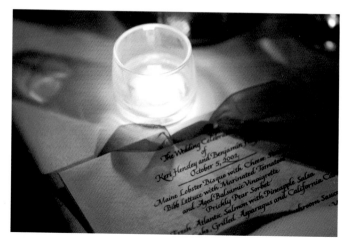

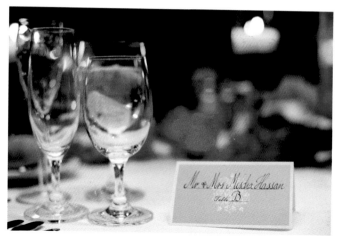

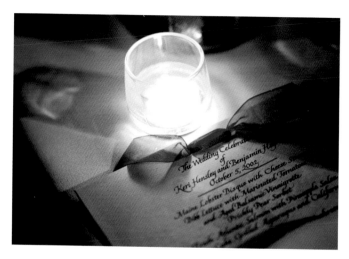

This is the colour balance when changed to tungsten. It definitely cooled down the photo. It's all subjective, but I am partial to the warmer image above.

Here, however, the flash is used. Despite being bounced from a ceiling 12 feet above the camera, the difference is pronounced.

TIP Keep a piece of grey card in your camera bag, to use for setting white balance.

Using flash

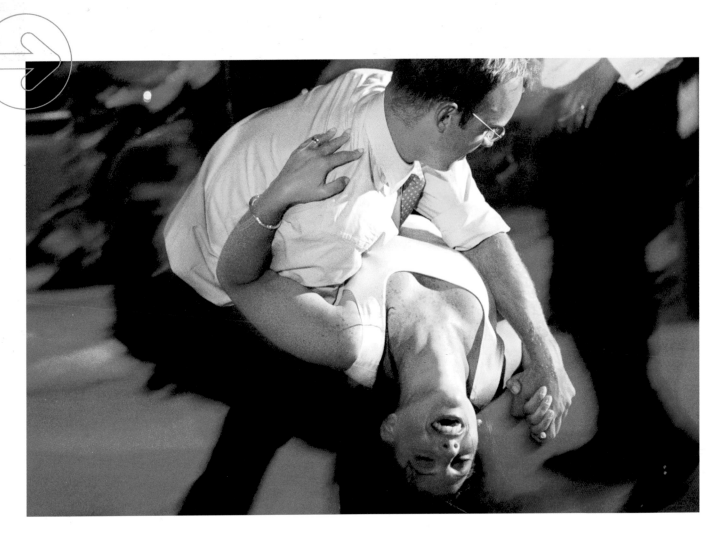

Flash units have improved along with the modern autofocus cameras. With these improvements, it is no longer necessary to calculate the subject-to-camera distance and then use a guide number to determine the camera settings (tricky in fast-moving situations without practice!). The new modern cameras and their dedicated flash units do this for you quickly, and with amazing accuracy.

In run-and-gun wedding photography, you will often use flash to freeze the moment that might have been lost if you were shooting only by available light. It is the skilful use of the flash (especially when mixed with ambient light) that distinguishes the pro from the amateur. Because the dynamic range of digital is narrow when compared to the range of colour negative film, the skilful use of flash is imperative when using a digital camera.

There are ways to use flash so that the look is less obvious. It is vital to spend some time playing with the camera and flash before a big shoot in order to make sure everything is working properly. Digital really comes through here because you can see the effects of your technique immediately. Remember that these portable dedicated flash units, while very

powerful, are still fairly small and limited in their range and power (mostly in the 2 to 20 feet range).

Look for low white ceilings, white walls, and even the dance floor (if it is a light colour) as surfaces to bounce light. Get the flash out of the hot-shoe and connected to the camera with an off-shoe cord in order to create lighting that is more interesting than on-camera flash.

Feel free to experiment – get creative and be fearless with your flash. Shoot safe images first, and then experiment. Push past your initial hesitancy and explore – you're not wasting film, so take chances. Try to make unique photographs at every wedding. It can be difficult, but if you force yourself to expand your repertoire, you will.

The flash must be used sparingly at weddings, depending to a great extent on the protocol and atmosphere. When you do use it, bouncing the light from other surfaces is less obtrusive, and can look better than directly lighting the subject.

This photograph was actually made with a flash on camera, and another flash off to the side to create drama.

In the shade under the canopy, the on-camera flash was used to provide enough fill light (but not too much) to read the expressions.

A flash held off camera, just below the lens, created dramatic lighting. A second was used to light the people at the back, and a long exposure completes the look.

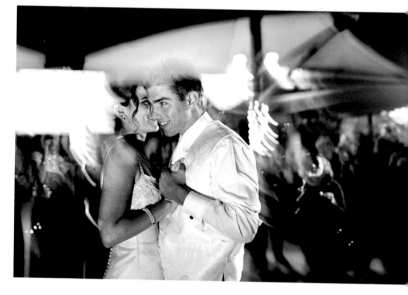

While looking very natural, this photograph was made with a flash unit aimed at the top of a very tall ceiling (about 12 feet) to spread the light evenly.

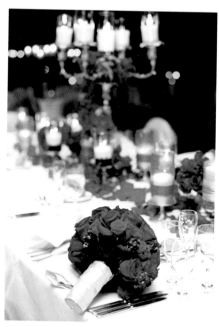

While I don't like using flash during the ceremony, I was able to use it here and it helped to clean up the foreground. I shot a limited number of frames to be discreet.

TIP If you must use direct flash, use a Stofen brand dome to diffuse and soften the light.

2 Taking great wedding photos

There are basically two schools of thought regarding wedding photography: documentary or photojournalistic on the one hand, and formal portraits on the other. Try both styles and see which 'fits' your personality. Look, anticipate, pre-visualize, shoot, and then continue to look some more. Aspire to take great shots that go beyond being just wedding photographs. Raise the internal bar and aim to be the best in your profession.

Planning the event coverage

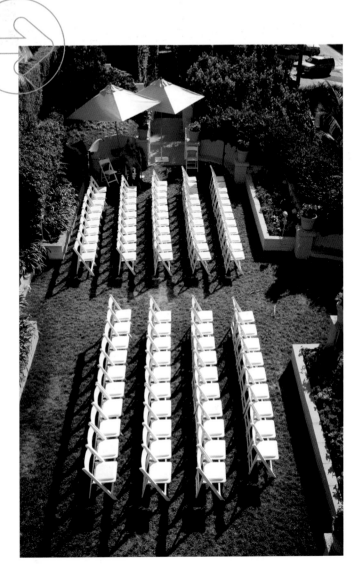

By getting to the location early I was able to see how light would be affecting the scene. I also saw a graphical set-up before the wedding. Using an overhead angle and moderate wide-angle lens, I was able to capture the elements of the pristine lines of chairs and the environment.

The couple requested a private moment before the group photos. It was nevertheless possible to capture the moment without intruding by keeping back with a 100mm lens (140mm efl).

It is also important to understand what their goals and hopes are for their coverage. Do they want a lot of portraits, do they want more photojournalism, do they want more black and white over colour – have they even seen your work?

Finding the right couples that fit your style is necessary. If you are a documentary photographer, and the couple are really looking for a lot of portraiture, it won't be a good match. The pre interview (or a Web review) is a great way to assess that fact. By the time you actually meet the couple in person for the first time, you should both be clear about style, and pricing. The Web allows brides to shop and to find answers to questions simply by viewing a photographer's website.

A working timeline of the day is helpful to good coverage. Knowing where and when things will be happening is important for planning purposes.

I also ask the couple to tell me the key people in attendance. For example, if a mutual friend introduced the couple, a nice candid portrait of that person would be very appropriate for their album.

Flowers tell me who is close to the couple. If you key in on the people wearing them, you can't go wrong. It's a safe bet that they are critical to the event – either in the bridal party or the members of the families.

Attend the rehearsal, if possible. It will give you an idea of the location, the flow of the ceremony, and give you a chance to meet the players so on the wedding day you will be known.

Shoot a casual portrait session with the couple before the day. Many photographers include them in their packages specifically to get to know the couple even better. You may sell portraits from the session, but getting to know the couple is the real bonus.

I enjoy getting to know the bride and groom. Get as excited about their day as they are. Try to find out the story of how they met, any information about their families, and special nuggets of information. I believe the quality of the images taken are directly related to the quality of that connection.

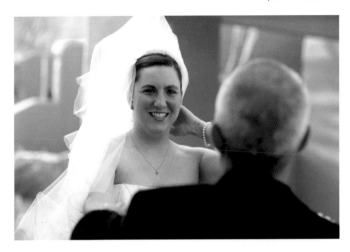

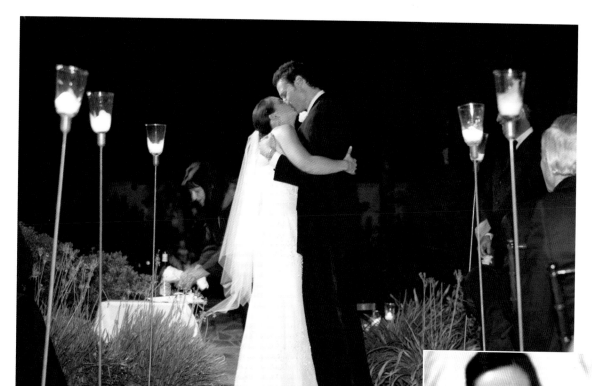

A must-have photo and I didn't want to take any chances, given the marginal lighting at the event. Even though I prefer to use available light, my thought here was the light was so low that movement might ruin a key photograph. Flash was the safe bet. If you have time, you can always shoot first with flash, then turn it off for subsequent shots.

On this occasion I was able to work with a moderate wide-angle lens, and used bounce flash to light the scene while still capturing natural moments.

I arrived early on this occasion, so the bride's family could get used to my presence, and relax.

Scouting the location

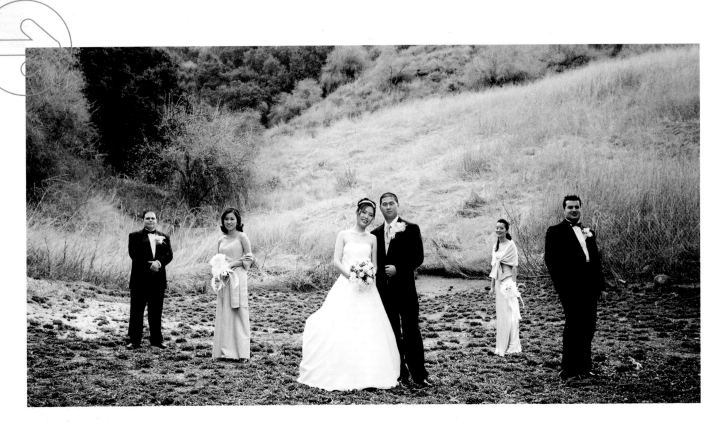

Getting as much knowledge as possible beforehand is essential. Ideally you should do a location scout of the church, the reception, and the drive between the two of them before the wedding.

It may be too far away for this to be practical. In that case, be sure to arrive extra early to the locations to get a chance to view possible settings for portraits, and make a game plan.

I also prepare Internet driving directions on the computer from my home to the locations in order for me to gauge the amount of time I need to get from site to site. I never want to be late for any reason, therefore I usually

double the amount of time the directions recommend. Once at the site I will be able to relax, get changed, and then scout.

If you do get to do a scout, it is best to do it at a time close to the event. By doing this, you can check out the quality of light and determine what will be necessary in terms of lenses, tripods, etc.

Some photographers prefer to arrive early at the scene on the day of the event, rather than do a scouting trip, so that they can just react to the things they see rather than being swayed by preconceptions from the scout trip, or viewing other photographers' work from the location.

Other photographers include coverage or at least attendance at the rehearsal the night before. As mentioned in the previous chapter this is a good way to check out the church, venue, and gauge the light. It is also a good time to meet the church coordinator or on-site coordinator.

Having that personal connection can help make the next day's coverage stress-free.

A normal focal length lens was important here, to keep everyone in sharp focus, with accurate proportions.

Here I used a short telephoto lens to compress the perspective, and the location still looks good thanks to its dramatic shadows.

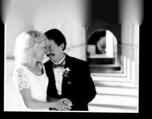
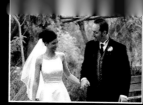

When you're looking at property, the estate agent's mantra is 'location, location, location'. In wedding photography, things are much the same, and the more aware of your surroundings you are, the more efficiently you'll be able to work.

The location coordinator made suggestions for portraits, saving valuable time and allowing me to shoot and then get back to the reception.

I set up the family photographs before the ceremony. A walk through of the grounds found this location that provided shade for the subjects. It required me to use fill flash to open the shadows and balance with the ambient light.

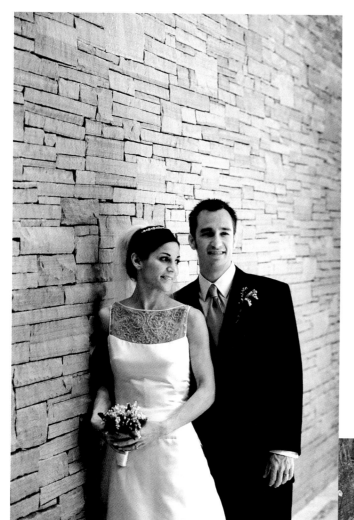

Having some special time with the couple gave me a chance to explore several locations, but since it's important not to waste too much of their time, the coordinator laid on a golf buggy.

Formal vs informal

As a general rule there are more production aspects to doing weddings from a portrait-style standpoint. Photojournalists tend to travel much lighter than their portraiture counterparts, with only hand-held flash.

I prefer less portraiture, though I want to do an excellent job in the time that we have. You should check with the clients, of course, but you will find that most brides expect to see shots of the following groups:

▶ Bride and groom
▶ Bride alone
▶ Bride and groom with the chief brides-maid/matron of honour and the best man
▶ Bride and groom with each set of parents
▶ Bride and groom with her family (and siblings)
▶ Bride and groom with his family
▶ The bridal party (with ushers and junior attendants)

Photojournalistic versus portraiture. Documentary versus posed. These are debates that have raged within the photo community for nearly twenty years and continue to foster ardent support from each side.

Despite our own inner photo battles about styles and which is better, brides expect a certain amount of portraiture on their day. The difference is that most photojournalists will shoot a very simple and limited number of portraits while traditional portrait photographers shoot more posed photographs.

These days couples are doing much of their research on the Web, at bridal fairs, by talking to their friends and reading magazines. Most brides will have a clear idea of the type of photography they want.

Some brides will want more portraiture than others by virtue of custom, tradition, or just plain desire. With photojournalism being written about in magazines and discussed on wedding chat rooms, it is becoming quite known and desired. Know your style, and know your preferences and then try to find clients that match both.

A less formal portrait of a bride shot only with available light and a large aperture on a short telephoto.

After the ceremony, a more formal portrait of the couple, lit with one light off to the right. It is not totally *traditional because it is not merely a tight portrait of the couple, but places the couple within the environment.*

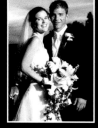

Whatever the style you adopt, portraiture is an accepted part of the wedding tradition. Don't skimp on the frames – have enough memory cards and shoot at least three frames for each group, more for bigger groups.

TIP Keep things fun for everyone: they are more likely to smile if the mood is light.

Sometimes it is possible to get the entire group together for one big shot, if space allows. Also remember that in a huge group photo, the individual head sizes will be so small that it might not be practical to shoot the photograph – it may be better to break the group down into smaller, more manageable groups and keep the head sizes larger.

I try to start with the biggest group and then work down to the smallest. This serves two purposes: it gets great reactions from couples when most people are present, and the energy levels are high. After the photograph, many will head for the reception, allowing me to concentrate on the smaller groups.

The key to good group photographs is varied spacing of the people, and having the subjects' heads clearly visible, and spaced throughout the frame. Having some people sitting or standing on chairs can help keep people visible. Get the attention of the group as you shoot. This is a bit odd for documentary photographers. Speaking a bit louder than normal and clearly, I often do a 'three-two-one' countdown to get everyone to smile when I take the photograph. For large groups I often take three to five images to ensure that everyone is looking and smiling appropriately.

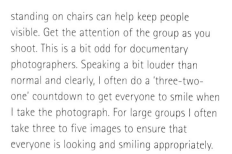
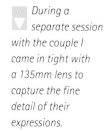

During a separate session with the couple I came in tight with a 135mm lens to capture the fine detail of their expressions.

The bride and groom kiss and dip at the end of a more formal portrait session.

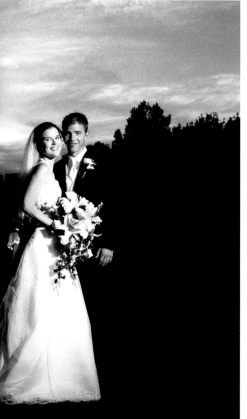

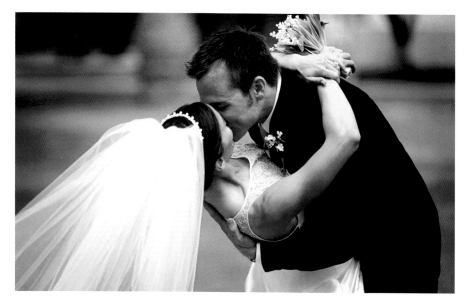

That natural look

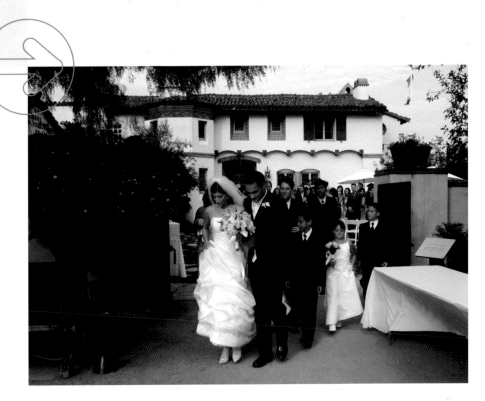

TAKING GREAT WEDDING PHOTOGRAPHS

To capture natural-looking images it's important to be accepted, to watch what is happening, and to be prepared to capture those moments you see. When you first enter the wedding with a big camera and a lot of equipment it causes a bit of a stir. It helps to introduce yourself to everyone, give a smile, and then ask people to try and forget about the camera as much as possible. If you say it in a joking manner, people tend to forget about your presence.

TIP You can help yourself out here by carrying the minimum of equipment, too.

The bride smiles as she is wished good luck by a guest. Keeping an eye on the bride is something I do constantly during the day. By quietly hanging back you are better placed to be able to record natural moments.

Racing ahead of the couple as they left the ceremony site, I knew this would be a photograph that had a natural feel.

Know your equipment and avoid fumbling with it. Be totally in tune with it. It should be second nature to see your moment, bring the camera to your eye, and shoot in one fluid movement.

Equally, you must be in tune with the emotion present to truly capture it. Try to stay ahead of the action both physically and mentally. I try to imagine what will happen next; look down the row and see who is being affected most by the day's events. If you want to capture emotional images, you must be constantly scanning for emotions expressed by the couple, their family, and their friends. I like to look at the faces, eyes, and expressions of my subjects. These reveal much to the viewer.

The fast zoom telephoto is a perfect tool for capturing natural moments. By using a large aperture, you can direct the viewer's eye to the emotion with the limited depth of field. The autofocus capabilities of these lenses has become so good that it is much easier to shoot them at maximum aperture than previously. Capturing real moments with normal and

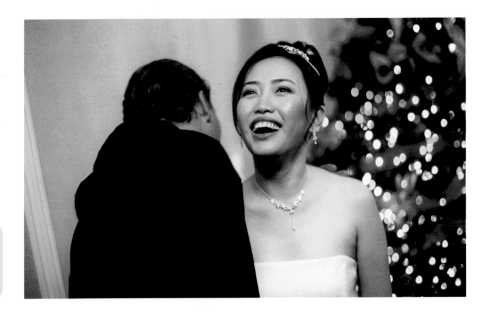

Deciding how to approach things depends on your relationship with the couple and their guests. If you're attending as a guest, you might find it easier to get close to your subjects, since they'll find you less intrusive.

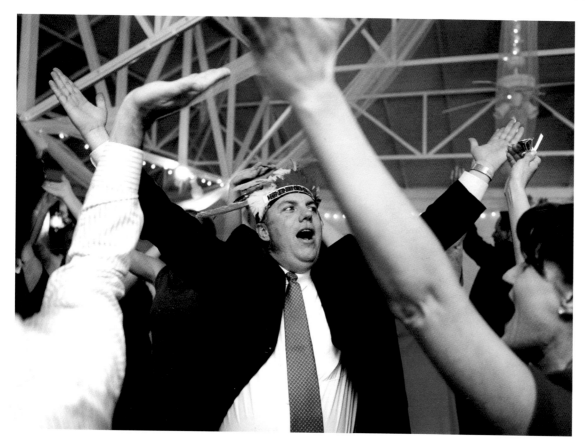

People eventually forget about me and just have a great time at the reception, shown here dancing to 'YMCA'.

As the reception gets more exciting, I often wade into the crowd with a limited amount of equipment, to allow me to move quickly, and so as to not bump into guests. Here I'm carrying only a moderate wide-angle lens and a flash gun.

wide-angle lenses, though, takes a bit more skill. You have to work closer to your subjects, so they have to feel comfortable with you, and your camera, in their midst. As the day goes along, I find I can work more closely as everyone gets comfortable with my presence.

The best photographs are the ones that capture people being themselves. I do very little prompting of subjects. Listen to conversations, listen to laughter, look for joy on faces, look for hugs and kisses. Follow your ears, your eyes, and your heart, and you'll be led to great emotional photographs.

I think dress can help set the tone. I tend to wear black to help blend in. This is appropriate for the California weddings I usually cover. Even though you are concentrating on moments and working hard, it's important to smile and enjoy the day as well.

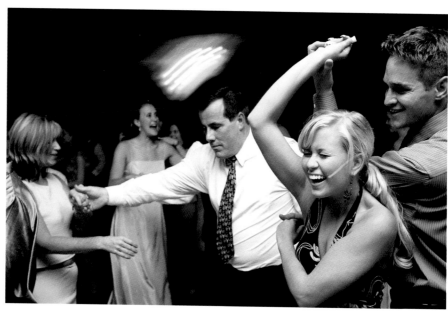

Capturing the moment

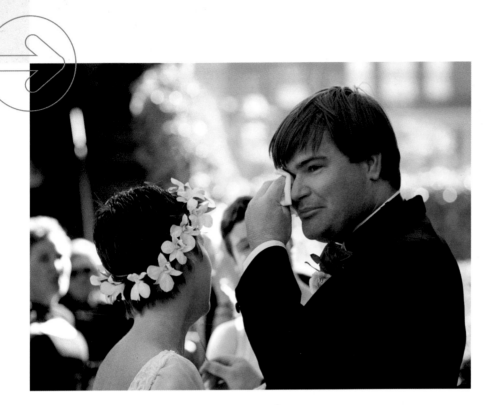

It is important to be unobtrusive and sense what is going on around you to capture the moment. It is imperative to know the players, and any special stories that make the photographs even more poignant to the couple (like divorced parents dancing).

I find that most of the photographs that I like are made close to, and facing, the subject. I want to see faces because faces reveal emotion. Emotion, after all, is what weddings are all about. Also look for overhead views and side views because they can add visual variety.

Having a camera that responds quickly to what I see is more important than a fast motor. I have found that my best moments usually happen on the first frame of a sequence. With fast cameras you can end up with a lot of ordinary photographs to have to sift through.

I will often work with more normal or slightly wide-angle lenses because of my proximity to the couple, and have a short telephoto handy to capture those moments off to the side. Even then, most of my favourite images happen in the equivalent of the 28, 35, 50, and 85mm range. I watch for big smiles and hugs, listen for giggles, and try to be aware of any sensory experiences that tell me what is going on. I think the best photographs I have taken are the ones where I had a feeling they were good as I took them. Be truly present to the event.

Try sensing the emotions the couple are sharing, try to imagine the feelings of the mother of the bride as she cries tears of joy at the event. If you can sense those feelings, you will be rewarded not only with great wedding photographs, but also by being moved yourself by the beauty of the event. That is what really got me into wedding photography – I was moved by every event that I witnessed.

 This groom was moved to tears during the receiving line. Staying well back with a telephoto lens, I was able to capture him as he wiped away the tears.

A gentle kiss from her father was captured with a 70-200mm zoom lens. This is a quiet image but I think it really captures the tender moment.

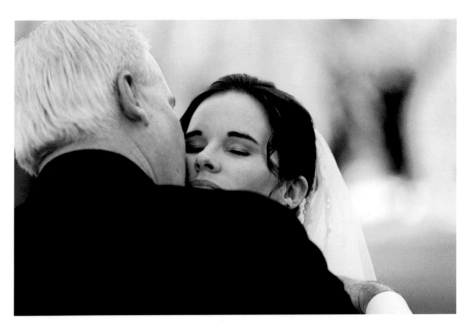

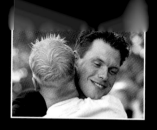

This is an area where digital cameras can struggle, depending on their lag and burst limit. Technology, however, is only part of the equation – get that first shot spot on and you won't need to worry about firing off too many more.

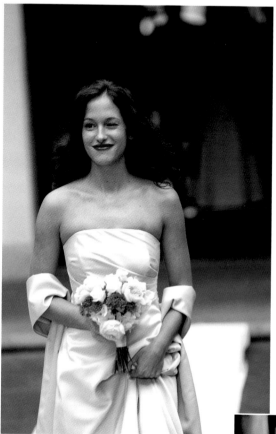

Waiting for the perfect moment when the groom throws a tie in the air is possible with a camera that responds quickly.

TIP → You will probably find your camera's burst limit varies depending on the format you shoot in.

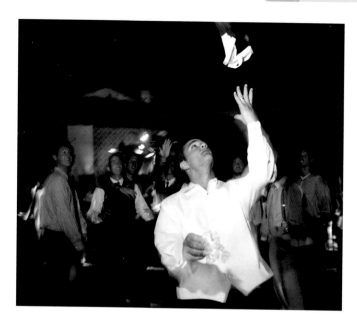

By tracking this bridesmaid as she marched in, I was able to catch a quick little wink. Having a camera that fires quickly is imperative when it comes to capturing moments like this.

I often hang back and watch at a reception. Here I used a 70-200mm zoom lens to catch these women reacting to a story.

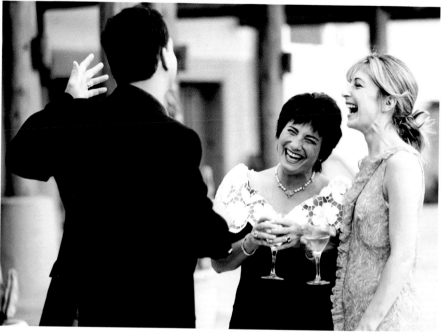

Get in close

Some brides will feel more comfortable than others in front of the camera. Using a short telephoto lens I was able to hold back yet capture details as the bride dressed for the day.

A long zoom (Canon EOS 1D 70–200mm) is used here, from close range, to take a tight shot of the bride's face before the ceremony. The alternative is always a prime lens and using your feet to zoom!

Getting in close really has two meanings. It has the photographic meaning of framing images that isolate certain items. The other is the psychological act of getting close to your subjects. Photojournalist Robert Capa said that if your photographs weren't good enough you weren't close enough. He said this at a time when a 50mm (normal) lens might be considered a telephoto. Time and technology have changed yet Capa's words are still true.

TIP Walk slowly, wear dark clothing, and carry a minimum amount of gear.

One of the most difficult aspects of photography at an event like a wedding, which combines personal feelings with public display, is choosing how to record the little details that make the day special.

Well-known photo director Rich Clarkson once said that he could tell a lot about a photographer based on that photographer's use of wide-angle lenses. If the subjects in the photograph felt comfortable and revealed their emotions to a photographer that close, they had done a good job in creating rapport.

Fast (light-gathering ability) and heavy zoom lenses are common today among wedding and editorial photographers. Zoom lenses allow photographers to stand back and work in low light. The telephoto aspect of these lenses also lets you isolate details and capture moments unobtrusively. These lenses have improved dramatically over time and their versatility has led to their popularity.

Manufacturers sell more zooms than fixed focal length or prime lenses. These lenses should not be discounted, however, because of their faster maximum aperture (allowing more light). They can often focus closer as well, helpful when capturing a telling detail.

These long lenses are often a good choice for some photographs at the wedding, though their size makes them less than discreet. Getting close in the psychological sense would mean working with more normal or slightly wide focal lengths such as 28mm, 35mm, and 50mm, which many good photographers use. One has to create a relationship with the

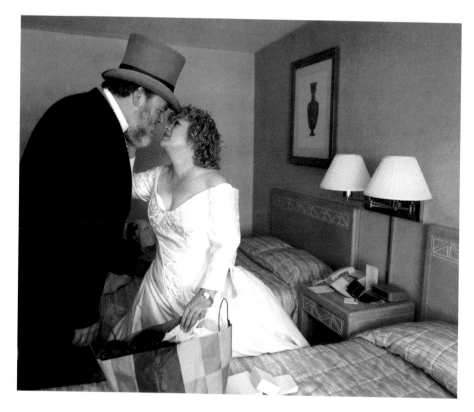

subjects to use these lenses effectively. It may be difficult for a novice to work in such close proximity to the subject, but in time they will feel more comfortable and confident, and the result will be improved photographs.

People reveal more about themselves to the photographer when that photographer makes them feel comfortable. A soothing voice and a calm demeanour really help ensure that the experience will be enjoyed by all.

Using a 135mm telephoto lens at nearly maximum aperture allowed me to capture a telling detail of the day. Because it communicates clearly and with impact, it could be used small in an album and still be read.

Using a wide-angle lens to capture this moment was possible because I had a good rapport with the couple, both at the preliminary meeting, and during the day. The hectic activities and strong emotions of the day often make people forget the camera is there – ideal for the photographer.

Action shots

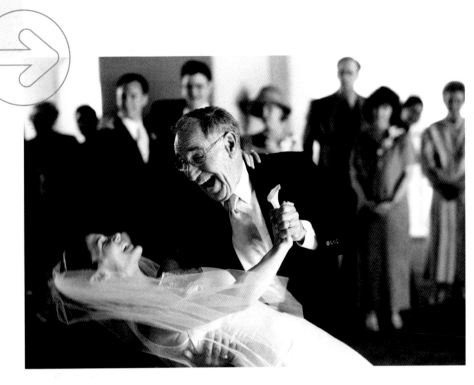

The best photographs capture the peak of emotion, body language, or gesture. This is the real art of still photography. Watching or shooting photographs at sporting events is helpful in learning how to anticipate the peak moment. Observe people naturally, even without your camera, and you will notice moments and body language, and can then bring that to your wedding work.

With the advent of autofocus cameras with high-speed motor drives, the technical act of capturing peak action is easier than ever. But despite the new technology and tools available, it still takes a trained eye with great hand/eye coordination to know where to focus, when to fire the shutter, and to decide which focal length to use, all at the right time – essential for great photographs.

To freeze or stop fast-moving action, you ideally need a shutter speed of at least 1/500th of a second. (If you time your moment well, though, you can stop action at the peak of the movement at 1/125 sec, but it's tricky.) Even with a shutter speed that high, you might still see movement. When you get in the 1/30 to 1/60 sec region, you will begin to start seeing motion blur, and that blur may be compounded by mirror bounce in your camera. Subjects coming towards the camera, however, require a slower shutter speed to stop the action than do subjects moving across the plane.

In low light situations, I will sometimes do a panning shot (moving the camera with the subject as they pass, which blurs the background) and sometimes will add a subtle

bit of on-camera flash to freeze the subject while still having a blurry background.

I like the look of a pan with a short- or medium-telephoto length lens. A slow shutter speed, 1/30 or 1/15, as the subject moves past you, should create a blur in the background.

Most of the work I do at a reception is with one strobe either on camera, or held off camera in some way. I will drag the shutter and set it in the range of 1/15 or 1/30 sec (perhaps even lower). Setting the shutter speed often depends on the amount of ambient light in the room, and the type of effect I am trying to achieve. The art is trying to find the balance between strobe and ambient. Some couples, too, will really like the motion effect, whereas others will prefer a more straightforward look.

TIP Remember to check things are OK using the camera's LCD as you get a chance.

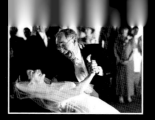
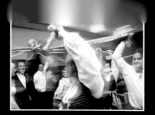

Conveying the action of a scene in a still shot might seem daunting, and perhaps even frivolous in the age of digital video, but it can really add spice to the record of the day, and (for most at least) it's still impractical to hang a video on the wall!

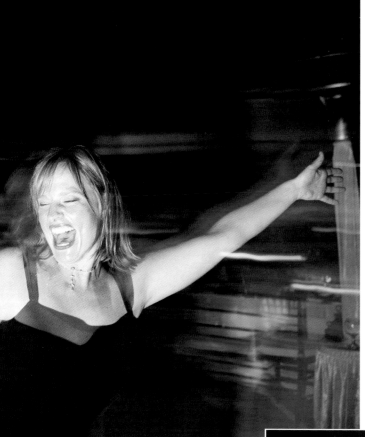

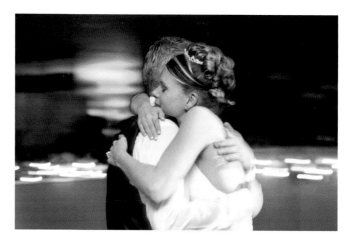

These dancers were frozen by flash bounced off the ceiling. Using a moderately high ISO (400) coupled with a fast lens (f2.8) I was able to shoot at a high enough shutter speed to stop the action.

The bride hugs her father after their dance. Using a short telephoto and flash bounced from the ceiling I was shooting and moving as I took this. The flash froze their expressions (for the most part) and the blurs were created because I was moving as I shot.

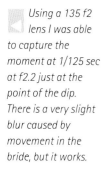

Using a 135 f2 lens I was able to capture the moment at 1/125 sec at f2.2 just at the point of the dip. There is a very slight blur caused by movement in the bride, but it works.

Using a wide-angle lens and flash off camera to the lower right, I moved with the bridesmaid as she was spinning and fired the flash at the peak of her expression.

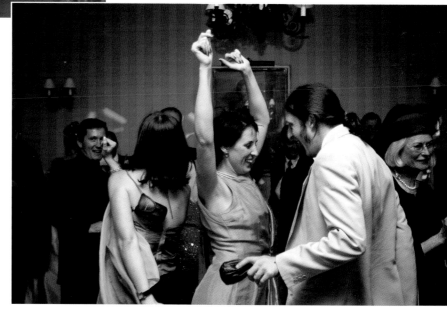

Backgrounds and surroundings

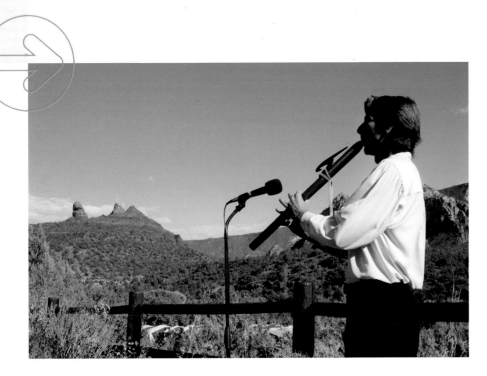

I am looking for great backgrounds every time I arrive at a location. It is critical to keep a constant watch on the background as it relates to your subject. After time you will begin to see this relationship instinctively, without even bringing the camera to your eye. Nevertheless, as you look through the viewfinder, your eye needs to be scanning the whole frame to ensure the backgrounds are clean, or at least not distracting. Every element of that photo has to contribute to its overall impact: nothing extraneous.

TIP If you do a location scout (*see page 32*) take note of good backgrounds.

Often when selecting a place for portraits, I start from the background and go forwards. I always want an interesting background, whether it be an out of focus solid pattern or an interesting patch of light.

I discovered I could get a much richer and more saturated blue sky by merely dropping to a knee to place the subject against the negative space that is the sky. Keep an eye out for any elements that will cause distraction, like power lines. While many of these distractions can be taken out, it is best to save time later by getting it right in-camera.

One lens that I find is very useful for placing people in a pleasing context to their environment is the lowly normal focal length lens (50mm in 35mm film). The wonderful thing about this lens is that it gives you a sense of the place without distortion, and has a slight compressing effect. If you use that lens at a large aperture (say f1.8 or f2 on a 1.4 lens), there can be a wonderful effect as you get closer – you're wide but not too wide, and tight but not so tight that you lose a sense of the locale. In so many weddings the location is a key aspect of the day and, while it shouldn't dominate, don't discount it by choosing only telephoto lenses that give no sense of place.

Many portraits are taken inside the church at the altar. I try to incorporate aspects of the altar such as the sacristy in the Catholic Church, or a cross, to help create a graphic element. Watch for anything growing out of heads in the background as well.

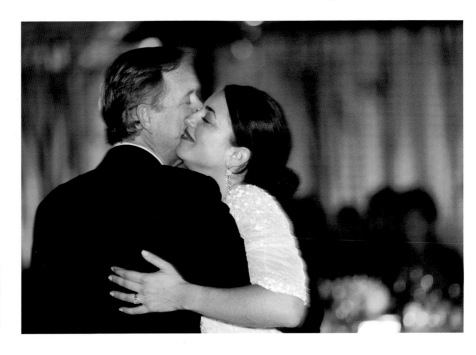

As with so many aspects of the wedding, it will really help to find out what the couple, and their family, especially like about the venue. If they've chosen it for a special reason, they'll be very keen to see it in the photographs.

By getting low and shooting up with a wide-angle lens, I was able to place this musician against the deep blue sky.

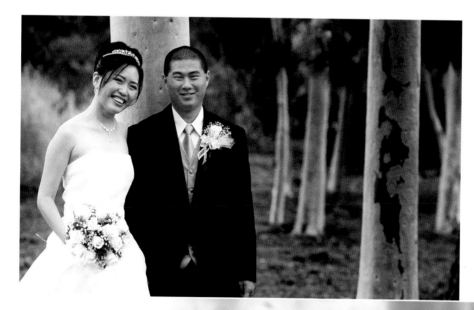

Scouting the area ahead of time, I loved the textures from these trees and thought they would make a great backdrop using a telephoto lens and shallow aperture.

When I first saw the low lights in the background I knew I wanted to use them in some way. During the father – daughter dance I backed up with a telephoto lens and photographed them dancing, using flash for fill. The warm glow of the lighted background became the backdrop.

The first thing I saw when arriving was the flowers in the background. I knew they would be a perfect backdrop if I used a telephoto lens (135 f2) at a large aperture.

The subtle texture of the drapes here made an elegant backdrop. I deliberately exposed to retain detail in the backdrop, and opted out of using a bounce flash to light the foreground. This was based on a decision that it would be more delicate if I shot with available light, though Photoshop was needed to open up the shadow area in the bucket while still retaining detail in the drapes.

Composition format

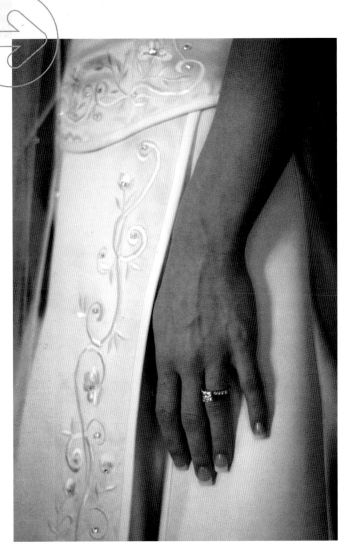

In this photograph, the point of emphasis – the ring – is placed on the bottom right third point of composition. Information you want the viewer to really pick up on should be at these weighted points.

The eye tends to go to the upper right third of the image, and then move in a circle throughout the frame. I find that elements that have weight, either the location of the eyes or the body, should be placed where these grid lines intersect. Sometimes, you can violate the rule of thirds and centre things successfully, but the traditional rules of framing give you a good basis for your work.

While I strive for great composition at the time I release the shutter, I don't let it get in the way of capturing a great moment. Sometimes a less than perfectly composed photo can be cropped in post-production, and sometimes it just does not work, but I will shoot first and ask questions later. I want to compose correctly when I shoot to save having to lose quality if I need to crop the photograph. Still, I'll take a great moment over great quality any time.

All the rules of good photography and composition apply to good wedding photography. I use the rule of thirds to create compositions. I find that I compose naturally with important elements of the photograph at the cross points of the grid imposed by this rule of thirds.

I wanted to capture the expanse of the scene as well as place the bride in a position that the eye goes to right away. Using the rule of thirds, I placed her along that imaginary line dividing the photograph in thirds.

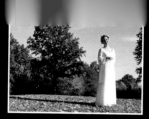

The traditional rules of composition apply just as much to digital as film, with the classic rule of thirds the easiest to follow. Simply divide the image into nine imaginary squares and place subjects on the dividing lines or intersections.

TIP Every aspect of the frame should contribute to the photograph.

With photos of the couple coming down a walkway, look for interesting lines that move through the frame and draw the viewer to the main part of the image. William Albert Allard, the great *National Geographic* photographer, stressed that every millimetre of the framing must include information you want to impart to the viewer. Really looking before shooting distinguishes you from those who fire off many frames to get just one. Equally, the good is separated from the great by attention to composition, as well as moment.

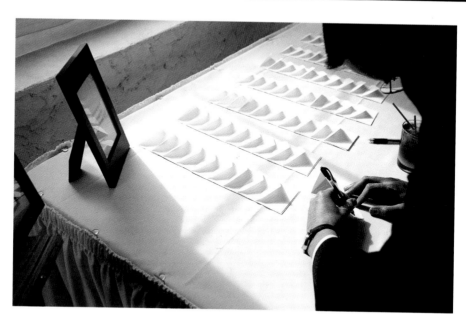

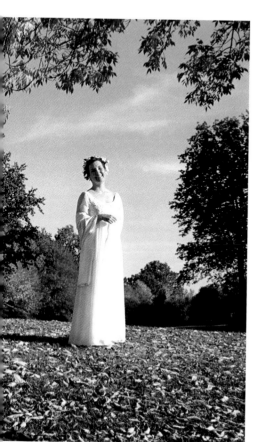

A guest signs a message to the couple at the reception. Again, the key action is taking place at the lower right third composition point. It also helps that diagonal lines move the eye in that direction.

A nicely lit group of wine bottles became the focal point in this scene setter that follows the rule of thirds composition. The diagonal lines from the ceiling also lead into the point of focus, as well.

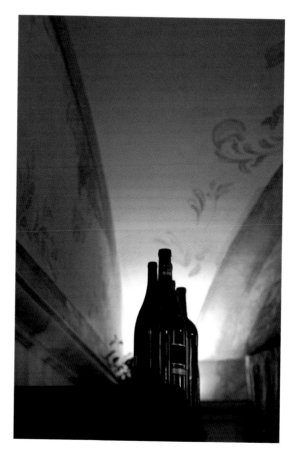

Seeing colour

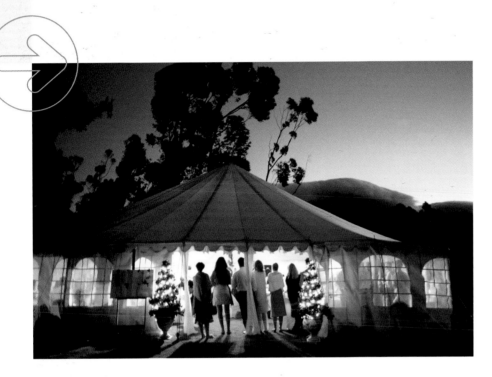

The elements of light and colour (and their artful use) are two of the main ingredients for great photography. Weddings are colourful events taking place at dramatic times in the day, so we benefit as photographers. Learning to combine these two to create exciting images is critical to success.

The couple really help us with this – they will select colours that reflect their tastes and flowers to accompany those colours (and the season). Dresses are then traditionally incorporated into their colour scheme.

The time of year, time of day, or the prevailing environmental conditions all add to these colour elements. For example at a spring wedding there may well be flowers in full bloom. These will naturally become part of the photographs.

Look for the colour in the light as well. There is a warm yellow/red/orange glow that comes with tungsten or quartz lighting. That glow permeates the photographs, and this warmth lends itself to wedding photography. Watch, though, that the digital camera doesn't create colour that is too garish. You will have to experiment to see how your camera renders tungsten light.

Be sure and watch colour temperature when you shoot in shade. Here, light tends to be blue, and it can be compensated by using your camera's shade pre-set, or cloudy pre-set. For more precision, take a custom white balance in that area. The use of a flash unit with a slight warming filter attached can also be useful in correcting this colour temperature.

Late afternoon light is also warm in its colour temperature. This time of day is a great time to work because the low angle of the light creates dramatic shadows. It doesn't last long, so work fast just before sunset. The light after sunset can be nice too. You can photograph the couple using flash with the sky as a backdrop at this time and it looks great.

The warm glow inside the wedding marquee works well with the rich blue from the sky above, darkening quickly after sunset.

Colourful flowers work with the colour scheme of the dresses. Soft, late afternoon lighting lets them stand out.

TAKING GREAT WEDDING PHOTOGRAPHS

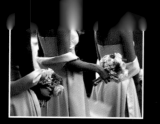
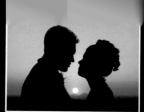

Colour is inextricably linked with light, so be aware of the time of day. There will be some shots you'll want to get in certain lights, like this classic sunset silhouette, so keep an eye on the time – even check the sunset time beforehand.

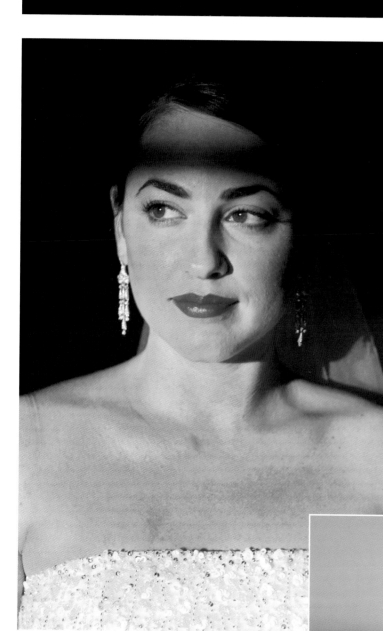

The bride steps into the warm light of late afternoon just before the ceremony.

A tungsten or quartz light aimed at the tree creates a splash of warm light on a daylight balance. Flowers add to the colour at right.

TIP Find out how your camera handles colour temperature and be prepared to adjust it.

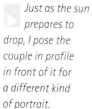

Just as the sun prepares to drop, I pose the couple in profile in front of it for a different kind of portrait.

Light – hard or soft?

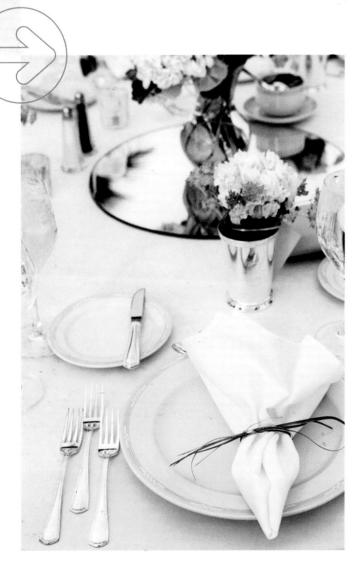

Late afternoon light in the shade can be very soft and create a nice effect, especially when photographing the place settings.

As the party heats up, I tend to try more funky styles of lighting such as using the flash off camera and to the right (above).

Light is the tool we use as digital photographers. The challenge is to use it artfully and dramatically, so that we are rewarded with successful shots.

Lighting great images with minimal equipment just adds to that challenge. We not only have to capture great moments and compose them artfully, but make sure it works technically too.

Weddings tend to be gentle events, and therefore usually tend to be photographed with soft lighting: light diffused through softboxes or pointed into an umbrella, bounced off ceilings (or walls) or diffused through some type of flash-mounted diffuser (like a Stofen dome).

Furthermore, many Photoshop techniques that are popular today (and will be mentioned later) can be utilized to create a soft, ethereal glow. It is a look that can be achieved at capture with certain filters in front of the lens, or added in post-production.

As photojournalists react to events, we usually have no choice in the light in which we work. If it is overcast or full sunlight, we only control the way we work in the circumstances.

The modern digital cameras and their dedicated flash units allow us to create looks that are either soft (by bouncing off ceilings and walls) or a harder-edged look by using on-camera flash directly (though it is not very refined).

The situation, the event, and the feeling you are trying to evoke in the photograph will dictate the flash technique used. I often use bounce flash as it is softer and more pleasing. It helps render detail in the foreground and shadow regions, which really helps when making prints. Window light can also create a very soft and flattering look, and if you have a large and broad light source, it can be very useful for the photographer. Be sure and watch your colour temperature/pre-set when using available window light.

When should you use hard light? This is great at a wild reception celebration or perhaps at a cigar-smoking

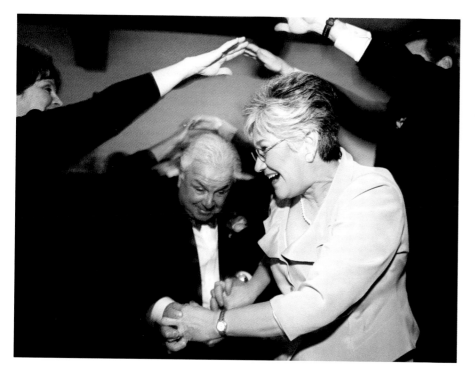

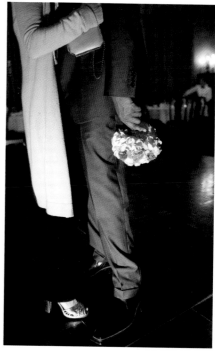

The parents of the bride go through an arch of human hands. A flash on-camera is used with a slow shutter speed to pick up some of the ambient light. By being light and mobile in this way I can get to where the moments are happening.

event at the reception because it gives the scene an edge, and really works with the energy in the group. I will often shoot early photos with bounce in order to capture a safe image, but then take the flash out of the hot shoe, onto an off-shoe cord, and begin experimenting with the placement and intensity of the light. This keeps things fun and exciting, and keeps me stimulated as a creative photographer – plus it makes the photos better and more fun.

By using light in an artful way, you will be able to conjure the feelings that you witness into your photographs.

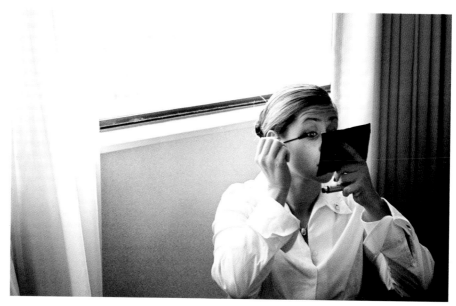

Window light can be very soft, and in this situation the mirror kicked back some light into her eyes, drawing extra attention to a key point.

The subject of this image is the way that he held that bouquet. By placing the flash on the ground it created a dramatic, low-lit edgy look.

Difficult lighting situations

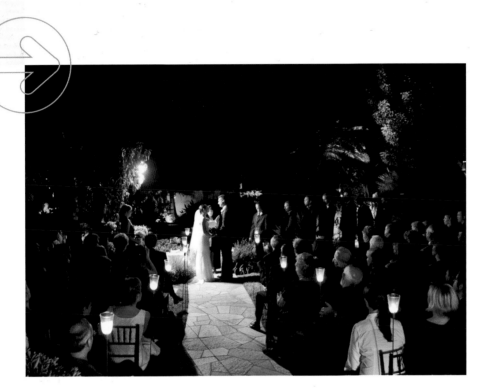

I expect that there will be lighting challenges at most weddings and I try to be ready for anything. In that preparation, though, I try to be ready in such a way that I will be able to tackle any lighting problems with things that I have easily on hand or can be quickly used.

> **TIP** In difficult light, try your camera's ISO modes, then select the best from the LCD.

The bride was getting ready to get into her dress and the light was fading. Asking her to stand and face the evening light created *a warm and yet dramatic classic look. Finally, through digital conversion to black and white, it takes on something of old Hollywood.*

This was a tricky shot because I wanted to maintain the feel of the event without having to *impose flash. Using a tripod, I was able to take in the scene and preserve the mood without blur.*

In harsh overhead lighting, I find it is best to find a massive area of shade with which to shoot photographs rather than have people looking directly into the sun. This high noon type of lighting can be converted to soft light by using a diffusion silk overhead.

Back-light is difficult with digital cameras. Cameras, while improving, still have a limited dynamic range compared to negative film, so it is easy to blow out the background. This might be useful sometimes for artistic purposes. The advantage of digital is the immediate feedback via the histogram. Only experience will teach what can and can't be reproduced in print.

Candlelight can prove difficult too, especially if you are using slower zoom lenses. Purchase a reasonably priced 50mm 1.8 lens (most major manufacturers make them, usually around £50) which is a small item to carry and can be helpful in these situations.

Don't be afraid to raise your ISO to allow you to capture by available light. The cameras are getting better and better at ISO ratings of 800 and even 1600. When you can capture in low light you can really capture the moment. The use of flash can sometimes destroy the

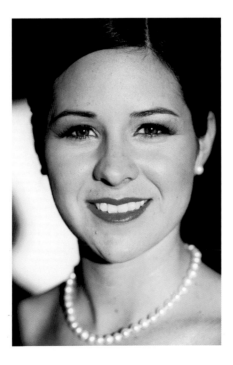

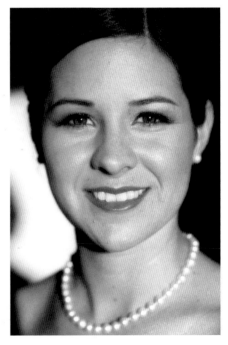

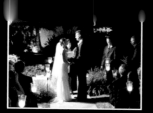
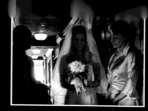

mood created by the natural light. It may be more risky in terms of focus, movement, etc., but that's part of the fun and the challenge.

These cameras do an amazing job in low light and scenes often look better on the camera than they do to the naked eye. Exploit that and take some risks. The photographs you take in this dramatic light will be distinctive and evocative. Use lighting difficulties to your advantage. For example, if you are fighting the back-light coming through the window, turn the couple into the light and use the window as a broad light source, or turn your subject into a silhouette. If light is harsh and directional it can often be warm, especially just before sunset in winter. Exploit that light: get a portrait shot in before the light goes away.

Using flash would have totally destroyed the soft light on the bouquet as the bride waits pensively for the start of the wedding. By dodging and burning in Photoshop her face was lightened just slightly to reveal more of it. This lighting was a mixture of daylight and the tungsten lights overhead.

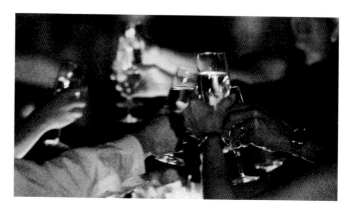

Always on the lookout for something new, I concentrated on the glasses during a toast. Lit only by the table candles and the light areas, I then converted the image to black and white, and added grain for extra drama.

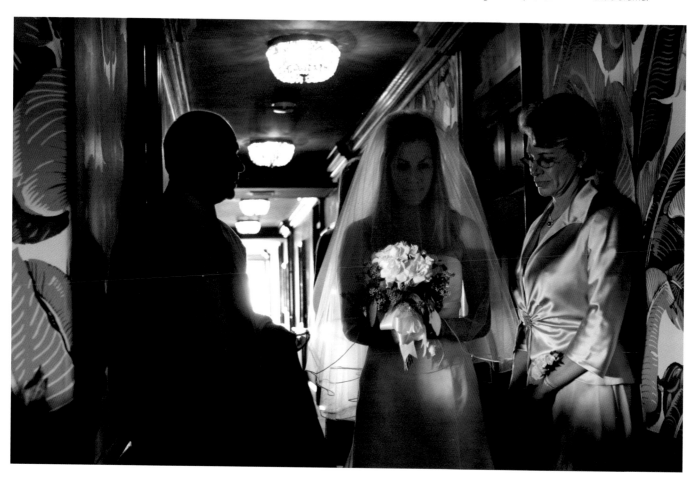

Shooting for post-production

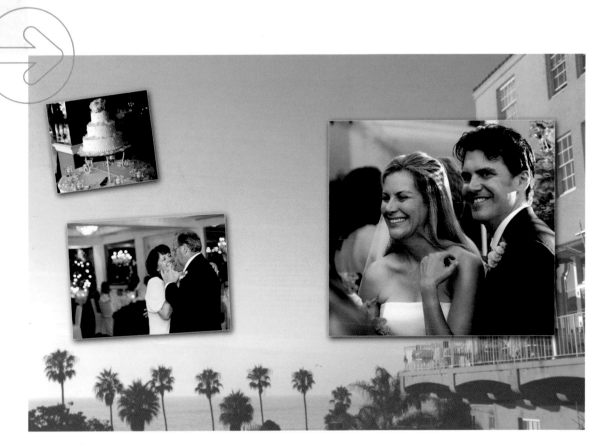

When I shot the scene, I had envisioned that it could be a full-bleed panorama that could become the backdrop for a layout from the reception.

With digital imaging you are not only the photographer. You can be the lab, and even the graphic designer, as well. Thus photographs can now be modified and used as an artful backdrop or design element.

While there is a classic sense of beauty and elegance to the older style matte albums, photographers using digital technology are not merely limited to that. The world of album design has been revolutionized by layouts incorporating either scanned film images or digitally captured images and their artful placement on the page.

Magazine style ('collage' or 'flush') albums allow you to use photos as large as a full-bleed panorama down to icon-sized photographs. Digital has pushed the evolution of album design, and can be something that distinguishes you from other photographers.

You can shoot now with the final album design in mind. A view of the reception location could be used as a backdrop to an opening spread in an album.

Details such as flowers, programmes, candles, etc., can also be used to create dramatic background images and part of a layout that is stronger than the individual photographs on their own.

I often capture the preparation photographs in colour, but prefer to see them displayed in those first few pages of the album as black and white, then switch to colour for the actual ceremony, in what is something of a nod towards *The Wizard of Oz*. Black and white has also made a comeback because many couples consider it stylish: an almost retro look.

I try to ensure that the digital effects in the album are understated. While I want them to appear contemporary, I also want them to have staying power over time.

In scene setters, you can capture the view with several exposures and then layer the images in Photoshop and paint back the light to create a better photograph than would have been possible in one image only.

TIP You can apply adjustment layers to individual layers to balance colour.

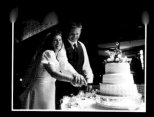

Shooting with post in mind allows you to consider the image's merit in different contexts. An image with poor colour, for example, might look good if only the light and texture were made visible, by conversion to black and white.

▶ Detailed shots of the intricate wedding cake are a must, and this image serves as the full page background. To make the collage, I combined the photograph of the cake with a photograph taken of the actual cake tasting. I converted it to black and white and then dropped it onto the page with the cake. I then took the opacity down a bit on the cake. To make it even more of a backdrop, you could apply a slight Gaussian blur to the lower layer.

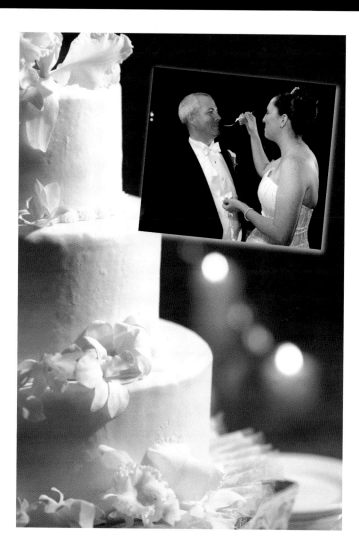

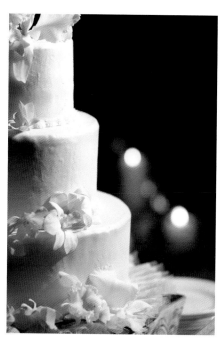

▣ Here the quality of the light hitting the couple as they cut the cake gives good tonal range, but it is unusable as a colour photograph. Rather than shoot with flash and destroy the wonderful light already present, I thought it would be best to shoot it and then convert to black and white in post. The texture and feeling are preserved without the yellowing light.

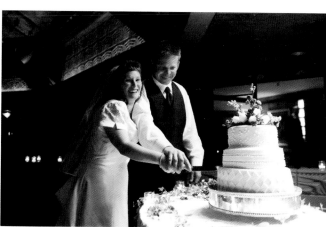

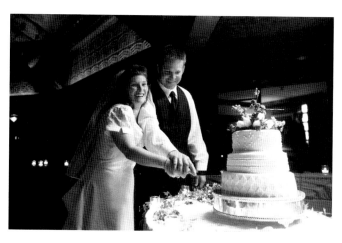

3 Essential wedding portraits

Couples expect a certain amount of portraits, even from photojournalists. Because of the distance many travel to a wedding, and the lengths they go to to look their best, almost everyone wants a record of the day. In this chapter we'll cover the important groups, as well as looking at some ways to make the process as fun and natural as possible. It's important, after all, to avoid making your subjects feel like hostages when there's a party in full swing.

The bride

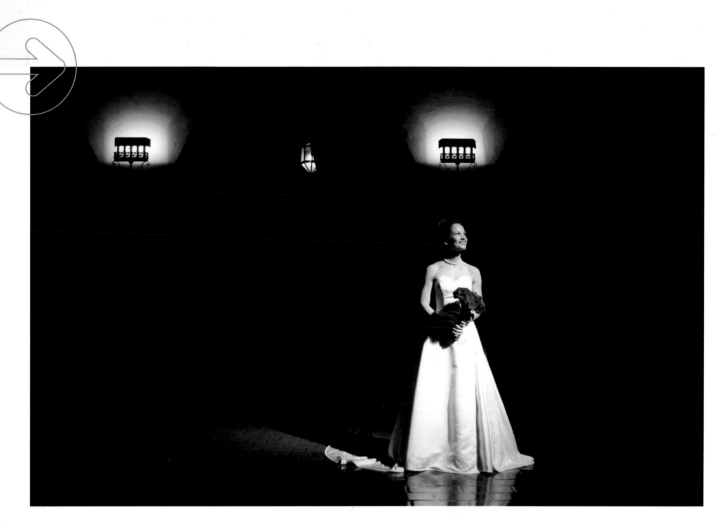

Great portraits of the bride are imperative to a successful wedding day shoot. This day is hers, she's never looked better, and it's your job to capture her in all her beauty. Most portrait time should be spent on portraits of the couple, and of the bride separately.

Use the light that is present. There was just a bit of sunlight coming through a window and it created the perfect light for the bride, in this case taken just after the ceremony.

If shooting outside, I look for the most flattering light that I can find. I look for shade or light from a large doorway or window. I usually photograph the bride alone at the church altar, as well. Look throughout the church for good light, such as the light coming through a stained-glass window or the light under the canopy of a walkway. These can also present graphic solutions to a portrait. Avoid direct sunlight because it tends to cause squinting, unless someone holds a diffusion silk over the couple to create shade.

When shooting in shade watch your colour balance. The light can be very blue and it would be best to create a custom white balance or use a shade pre-set on the camera (or do it in post-production if shooting RAW).

In some places there is a tradition of offering formal bridal portraiture before the wedding day. This is sometimes done in a studio, or on location, and it allows the bride to have a glamorous portrait taken before the day. This photograph might be displayed at the reception location. Some casual couple portraits shot before the wedding day may be part of a signature book. This can be signed by guests, and given to the couple as a memento.

During the reception or cocktail hour, look for reactions from the couple, and especially the bride. Try to capture smiling, laughing, or reactions that will truly remind her of the joy she felt on this day. These shots can be more telling and revealing than formal portraits.

Again, photographic philosophy will dictate the style of those formal portraits. Some will prefer to use umbrellas and double lights, others might try to shoot outside or with minimal lighting equipment at the altar.

Portraiture is a matter of taste, and it is worth remembering that – whatever the views of the couple – there might well be differing tastes amongst the various guests. It certainly doesn't hurt to cater to as many as possible.

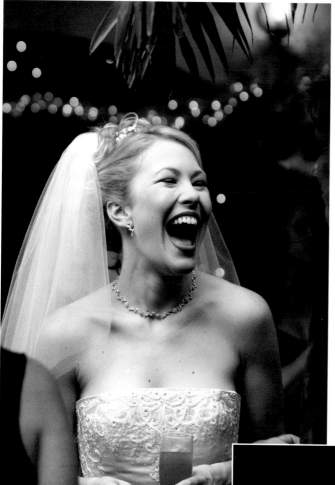

Watch the bride as much as possible throughout the day. This natural photograph was captured straight after the ceremony as the bride was greeted by friends.

Driving to the church, the bride sits quietly in the back of the limousine. The dramatic late afternoon side-light adds colour and drama to the scene.

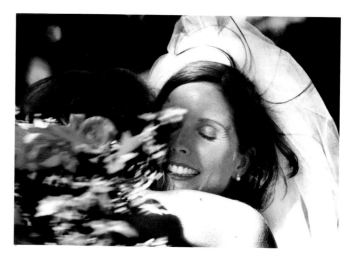

At the cocktail hour, the bride is festive and it shows. I would rather spend less time shooting formal portraits to capture a real moment of the bride laughing with friends and family.

TIP
Arguably the bride is your most important subject: always know where she is.

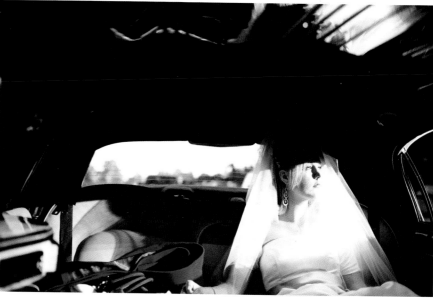

The groom

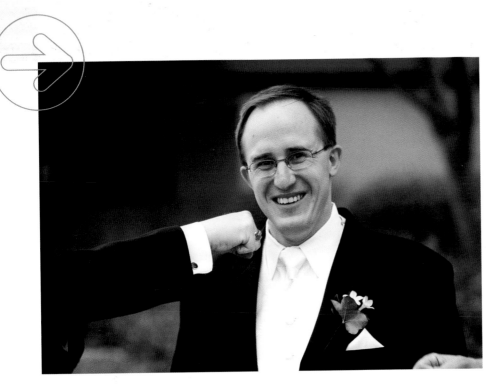

Pity the groom. He is often the one most left out of the coverage. I suppose it is understandable – after all, it is often seen only as the bride's day! Still, I think it is important to capture a revealing look at the groom in formal or informal portraits before the ceremony, and I watch him throughout the day to try to capture a great informal portrait of him as well.

It is important to establish a rapport with the groom and his groomsmen, and get them comfortable in front of the camera. I think it might be a bit more difficult to get the groom to relax in front of the camera than the bride. Perhaps it is because brides thrive in the limelight. With a lot of real smiles and natural banter, you can lighten up the groom and his mates, who will often be teasing their friend who is about to be married.

As with the bride, I tend to think the best photographs of the groom are the ones that show him naturally and less formal. I also love to show these photographs in timeless black and white, even if they were captured in colour.

Look for those moments when the groom is with people. Get to the correct position (usually close to front and centre, perhaps standing back with a longer lens). Look at the eyes and look for the natural smiles – these are usually best seen from a front angle.

I look for large, flattering light surfaces and if I have to use flash I try to bounce it from a ceiling or wall.

For portraits, I tend to use a short telephoto prime lens or the short end (around 100mm) of a telephoto zoom lens. This lets you stand

You have to admire the exuberance of this groom as he dons his jacket before the ceremony. A little bit of flash bounced off the ceiling filled the shadows and also created a bit of blur which adds to the frame.

back so you don't distort the features, and as an added benefit you get to blur the background (if you use a rather large, or wide aperture). The nice thing about this is that you then concentrate on the face and expression of the groom. I like to have the body at a more angled view so that there is a sense of depth due to the angle. Having someone immediately next to you and engaging the subject can help make him more relaxed in the photograph.

Before the ceremony, during a portrait session with the groom and his groomsmen, one of them (mostly off camera) was helpful in eliciting a smile from the groom!

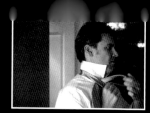

Perhaps even more so than with the bride, the groom will benefit from being shot outside the formal context of portraiture. The images on these pages reveal a lot more emotion than a posed photograph could.

▨ During the speeches, the groom smiles and gestures to his bride. Here his very natural smile is caught with soft light bounced from the flash off the ceiling.

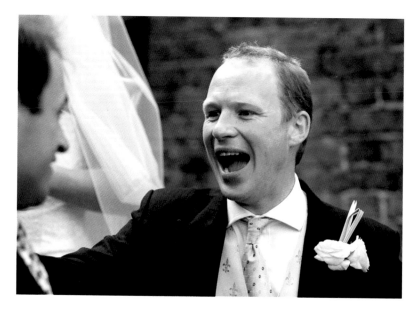

▨ During the receiving line, the groom greets family and friends. This is a great place to catch wonderful expressions.

▨ This is a simple, natural light photograph of a groom before he got married, taken with a moderate telephoto at a larger aperture.

The couple

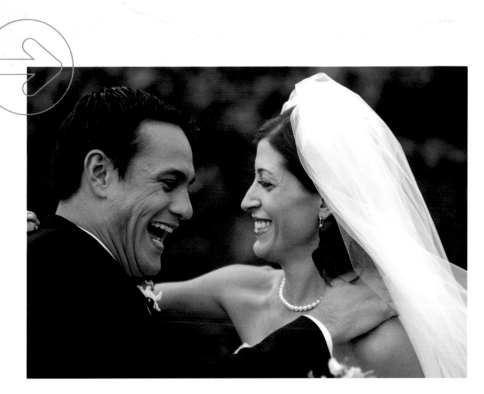

Again your style will dictate your approach. I favour the natural, more candid look and am less formal than other photographers.

I like to make the couple portraits the last item on my portrait list. I like to have very few people around when I do these photographs because I want to try and let the couple have some quiet time together to gather their thoughts after they have just taken such a life-changing step.

Sometimes the only place to do these portraits will be at the church altar. It can be nice, especially if the altar is ornate or beautifully decorated.

My preference, though, is to photograph the couple away from the crowd in an outdoor setting in an area where the light is soft or shaded. Bright, harsh sunlight forces me to use fill flash. This tends to look artificial to me, unless handled very delicately.

These are the most critical portraits of the day. These will be the photographs that sit atop pianos, hang on walls, and are passed down through the generations. Some of the only photographs I have of my grandparents together were the ones that were made on their wedding days. I try to remember this when taking these photographs. These have to be great, and are therefore the ones on which I try to spend the most time.

It is always nice to hang back and just watch as the bride and groom chat and laugh with each other after the ceremony. Here was a little session where I asked them to just talk while I hung back with a telephoto and just enjoyed the moment of them laughing.

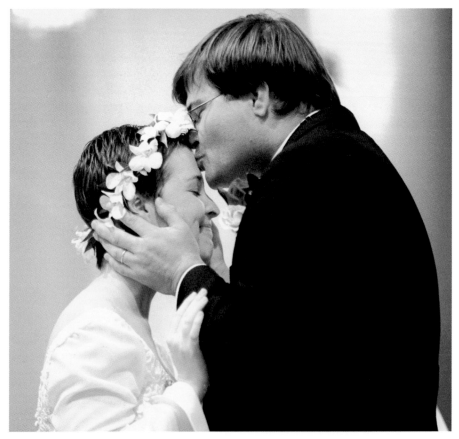

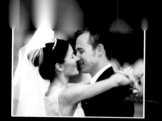
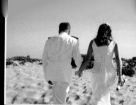

Portraits of the couple are an excellent opportunity to take advantage of your research, whether that's meeting and planning, or knowing them your whole life. Try and inject a bit of personality by catching them at quiet moments.

Current flash units with through-the-lens (TTL) capabilities work well for this and allow you to put a small amount of flash to fill the shadows.

Try to 'kidnap' the couple for a 10- or 15-minute photo session. Often I will ask them to face each other and just stand back with a longer focal length lens to capture the interaction. Some of my favourite portraits of a couple are the ones that naturally occur during this session and are captured from afar.

I also look for the couple together during the reception. I'm looking for natural reactions, as they talk with their friends. I look for body language – the hug, the glance, the way they hold each other's hands. These say a lot about the couple and their relationship.

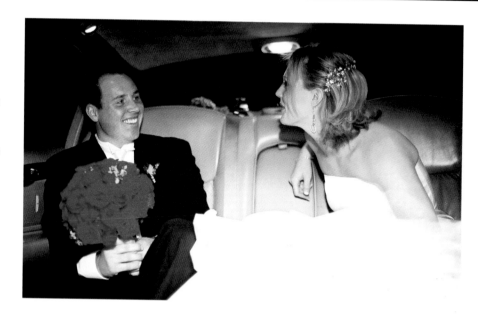

Riding to the reception, the difficult work behind them, the couple can relax and enjoy each other's company.

This is obviously not a posed formal portrait of the couple, but the moment is better than anything I could ever pose. This was the photograph from the day.

The hand-in-hand photo from behind can be a great closing image to an album.

The best man, maid of honour, & bridesmaids

For purposes of layout in the album, if all the photos of the attendants are a similar size they work nicely together. When shooting these and other photographs throughout the day I am constantly thinking about which photographs will be played large in the album, and which will be played smaller. Coming from an editorial background I tend to think of dramatic photographs played for maximum impact, and think the best horizontals should be run large and the verticals could run as a full vertical. This will not be the case for most images, but it's a goal for my favourites.

If I can get some private time with the couple, I will often add the maid of honour and the best man to the group, to show their relationship (and they can also help elicit pleasing expressions). With them present, I have an 'assistant' for holding a reflector too!

The best man and maid/matron of honour are clearly some of the major players in the day's events. (I also try to make a nice portrait of the couple with each attendant). For the portrait of the couple with the best man and maid of honour I tend to shoot with on-camera flash, diffused with a Stofen dome to slightly fill the shot. I might use available light, if I am in an area that is softly lit, or open shade. Be careful of colour balance. A custom white balance or a shade pre-set colour setting might be in order to make these consistent in colour.

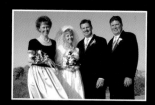

Not only are the best man, maid of honour, and bridesmaids important subjects, they're also your allies in getting some great action shots. These people, after all, know the bride and groom the best, so will be able to offer you some pointers.

I like to take the couple away to a location, if possible, for a special session. It can be helpful to bring the best man and maid of honour as well.

A simple portrait of the groom (left) and his best man, lit with natural light in the open shade. This would look beautiful converted to black and white as well.

Groomsmen do their best 'Reservoir Dogs' impression.

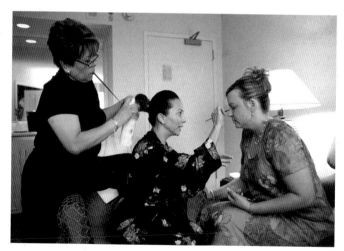

Running late, the bride (centre) gets her hair done as she does the make-up of her bridesmaid in the hotel room.

TIP Ask the groups if they have any gestures or poses they like to do when they meet up.

The parents of the couple

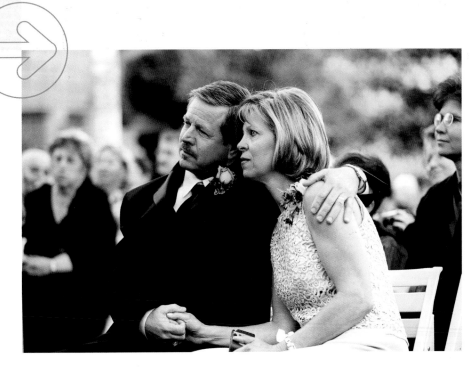

A great portrait of the parents of the couple, either posed or natural, is another photograph with high priority at the wedding. If the couple chooses not to see each other before the event, I will make a portrait of each with their parents before the ceremony. I will then take photographs of the couple after the ceremony, with both sets of parents, and then with each individual set.

I try to watch the parents during the ceremony if at all possible and try to capture something that demonstrates how they are feeling about the day.

Blended families are a fact of life at many weddings, and can be a bit stressful for the couple and the photographer. Try to find out the family dynamics and relationships before the ceremony – it will help in this situation.

When I am shooting these formals, I try to shoot at least three photographs of each grouping to avoid any blinks. Also, get everyone's attention before shooting to get the best expression.

Even with the advantages of digital (less restrictive than film in terms of the volume of images), I still don't want to shoot too many, as this involves more post-production and also tires the subjects.

Keep the parents on their child's side during these photographs.

During the ceremony, I'm constantly watching the parents for any special emotion, or reaction to events like speeches or dances. Watch for the mother of the bride during the bride's dance with her father. That can create some warm and wonderful photographs.

The mother of the bride has a laugh during the preparation for the wedding – she was very comfortable in front of the camera.

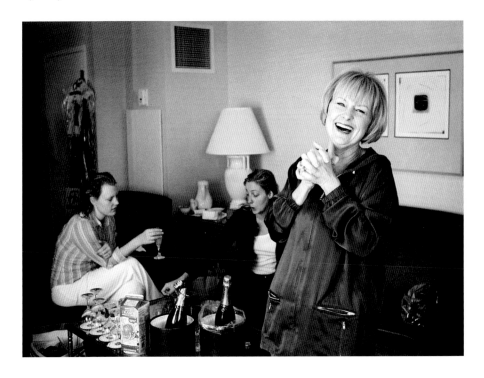

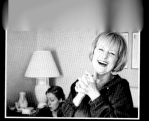

Capturing the parents is really an opportunity to let your photojournalism skills come to the fore. Be on the lookout for moments of exceptional joy or when people are simply overcome. It's a bit 'tabloid', but the shots can be touching.

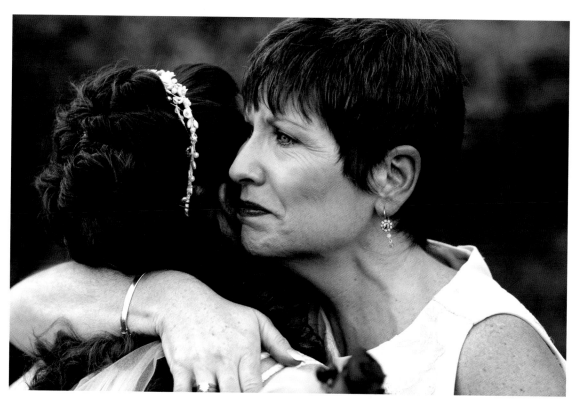

Mum hugs her daughter immediately after the ceremony. Watch for these special moments that capture the most emotional parts of the day. Again, this was captured by standing back with a short telephoto lens.

Mom wipes away a tear next to her husband (right) during the ceremony.

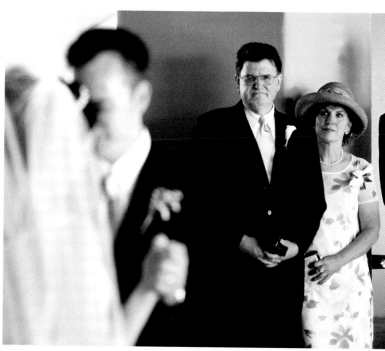

The bride and groom dance as Dad (centre) watches proudly from the back.

A moderately long telephoto lens with a wide aperture allowed me to create this composition.

Small family groups

For some photographs, shooting the groups is almost as much fun as teeth-cleaning. In the past I used to dread doing group photographs because it meant I had to change hats from documentary photographer to director. I wasn't comfortable in that role, but, in time, I found that giving clear directions led to fun and more fluid shooting. I actually quite enjoy them these days, although I still try to have them wrapped up in about 20–30 minutes at the most.

I try to get the key family groups. They are:
▶ Bride and groom with each set of parents and then both sets together with the couple
▶ Bride and groom with grandparents
▶ Bride and groom with each of their respective families

▶ Bride and groom with their families (then add husbands, wives plus their children)
▶ Bride and groom with special people – aunts, uncles, godparents, etc.

The optimum size group (for my tastes) is about eight people total. At the right church or location, it is easy to stagger the placement of people using stairs or even chairs. This is a manageable size and helps everyone's attention stay on me as I shoot. The larger the group, the tougher it is to get everyone's attention focused at the same time.

I also like this size group because the photographs are easier to view in print than huge groups, as the head sizes of the people in the photograph are that much larger.

I place the bride and groom in one place and then build the group around them. I find this is easier because there is less time wasted adjusting the train of the bride's dress, and the couple as unit, since they stay in place.

By keeping things moving in this way the portraits are done quickly and the guests allowed to get to the reception. There are also often tight time constraints imposed by the church or the venue to complete the photographs after the service.

I got on a chair to get a slightly different angle on this group. The on-camera flash provided the only illumination, but it was diffused in a Stofen dome to get the look right.

Digital provides two advantages in group photography: firstly you can check to see if anyone blinked using your camera's playback facility, and secondly you can edit or merge images later in software to remove problems you miss at the time.

Small family groups

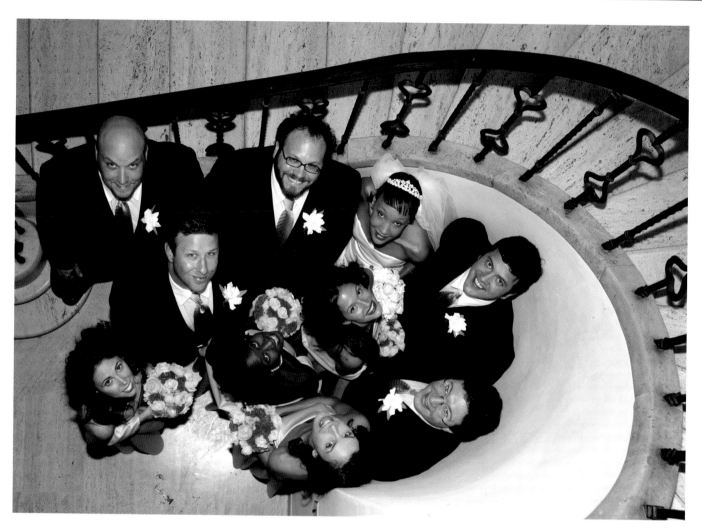

A simple post-wedding group photograph at the altar. Keeping it simple helps everyone get to the reception faster! A wide-angle zoom with on-camera flash fill diffused through a Stofen dome provided the illumination.

When shooting the portraits digitally, shoot them at the highest resolution possible for the camera. This allows for larger usage later. If there is any cropping or manipulation, there is more data to work with, which really helps. (Just remember to set your resolution to your preferred setting for documentary work after.)

Many photographers will shoot with the camera RAW format that gives them the opportunity to tweak the files after the fact. This can be very useful for the wedding photographer as it gives a little leeway when exposing, more akin to shooting with colour negative film.

A different take on the group photo, taken from above in the staircase. With a subtle on-camera flash, the advantage of this angle is that we see more of the subjects' faces.

TIP Take advantage of any features of the location, rather than using a backdrop.

Large family groups

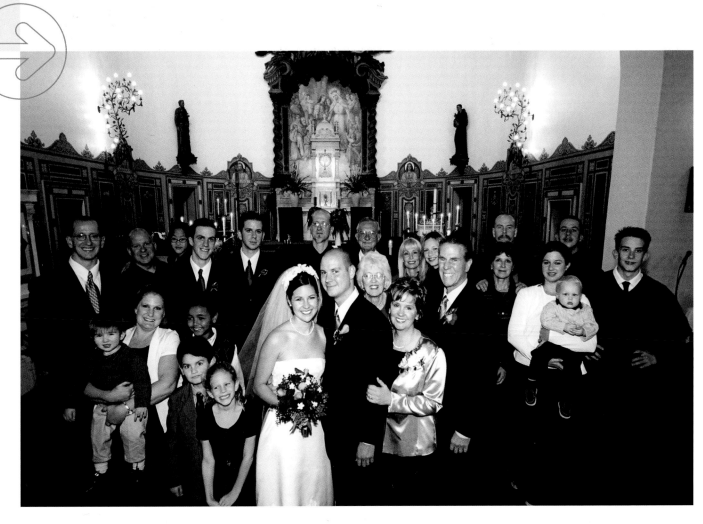

Large groups are a challenge to photograph because the larger the group the smaller the size of the individual on the photograph. It is also a bit tricky because the numbers make it more difficult to command attention, and there is a risk of people blinking during the photograph. Because they are the toughest to do, I like to do them first. There is less of a crowd afterwards so it's usually a lot quieter.

I learned from another photographer that it is imperative to have all the attention focused on me during the portraits. This allows you to get better photographs with fewer images shot.

Determine where you will shoot (I often opt for the altar for these large groups because there are often steps with which to arrange people), and begin by placing the bride and groom. Build out from the couple, placing family members on the appropriate side. Look at the scene from camera angle as you build it and make sure that everyone can see the camera lens. I tell people if they cannot see me, then I cannot see them.

I try to limit the size of the larger groups if possible, but sometimes there is a request to have everyone in the image. I honour it even though this might mean that head sizes of the

people, especially in the back rows, will be quite small. Be sure your camera is set to the highest resolution possible.

With a large crowd, it is important to get everyone's attention on the camera. I speak more loudly than normal during this time. I also helps to have the camera on a tripod because it will allow you to make eye contact with the subjects (this could be applied to all the group photos as well). Use a cable release to trip the shutter if on a tripod.

I will often do a countdown (three-two-one) to make sure that everyone's eyes will be on me with a great smile during the time of the photographs. For large groups I will take a minimum of five images, and often more than eight, to ensure that I have a frame in which I have everyone's attention.

Large groups present a challenge to the digital photographer as resolution becomes an issue. The smaller the subject in the frame, the fewer pixels that make up their image, so there is less detail. Be mindful of this trade-off.

I wish I had a better alternative to the large group at the altar scenario, but I'm afraid I don't. I dislike really large groups for the simple fact that it is difficult to see everyone. When doing a group of this size make sure everyone is looking at the lens, especially the little ones.

To have the women seated is a convenient way of varying the positions of the people in a group, especially when no altar or stairs exist.

Here I was trying to create a dynamic and interesting photograph of the bridal party. It was achieved by breaking a few rules on this one, both compositionally (with that dominant sky) and practically (by having everyone face the light). I had to ask everyone to close their eyes, then open them just before the photo was taken. That helps prevent squinting in a bright situation like this.

TIP As well as using your camera's highest resolution, never use digital zoom.

4 Special wedding moments

You just have to watch any film that features a wedding to know what the 'special moments' are. They're those clichés that the audience simply will not be happy without: the exchange of rings, the best man's toast, and the throwing of the bouquet. In the movies, of course, all of these elements will be frustrated in a dramatic way, but you'll probably find that's not the case on the day. Either way, these moments will need your attention.

The arrival of the bride

Even though I rode with the bride and her entourage in the limo, I hustled to get out of the car to make this photograph of the bride's arrival at the church. This was shot in the late afternoon light with a normal focal length lens at a very wide aperture.

After getting out of the limo (at right) the bride surveyed the scene lit by the late light prior to the wedding ceremony.

During the ride, I will cover myself by shooting photographs with fill flash (if I can bounce, I will, but it might be too confined for that). Then I take chances with available light – a little risky because of the slower shutter speeds, but the shots have a more natural look. If you work with a second photographer, they can be stationed with the guys, or waiting at the church when the bride arrives.

I look for photos that show her arriving, but ideally place her in the context of the location. I find that a normal view lens, or a slightly wide-angle lens, lend themselves well to telling the story without taking out too much of the setting, or distorting what you see.

Look for hugs from family and friends when she arrives. With a longer telephoto lens, look for details that show parts of the bouquet, her face, her expression, her friends' expressions and the like. Be constantly surveying the scene and look for people who are highly expressive or effusive, and try to key in on them.

Many weddings that I document take place entirely in one location, so sometimes the best arrival photos show the couple as they come into the reception area. Watch the expressions of the couple the instant they see their friends, and also as they pass through the crowd.

The bride will often get ready at a hotel or other venue (sometimes the location of the wedding itself). Brides being married in church are often chauffeured to the location. I prefer to ride with the bride to the church if at all possible, then hurry out of the car to photograph her as she gets out. Sometimes parents and well-wishers are there.

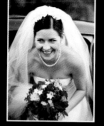
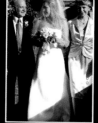

This is the opportunity for you to show the bride as the star she is for the day. All eyes will be on her, and so should your lens. Where possible let your composition emphasize her at the expense of others.

TIP Since dresses are typically white, be wary of overblowing the highlights.

The entire wedding and reception took place at an ocean-side mansion, and this shows the couple coming into the reception area during their grand entrance. Originally captured in colour, it actually makes a stronger image in black and white.

The bride arrives for the ceremony and is escorted by her parents. Keeping back with a telephoto zoom lens allowed me to compress the perspective and fill the frame as they walked towards me.

Escorted by her father, the bride arrives for a simple outdoor wedding in the fading light of the day. Using a high ISO and a fast moderate telephoto lens allowed me to stop the action without having to resort to using flash, which would have taken away the feeling.

The marriage ceremony

There are four basic areas to work when shooting the actual wedding ceremony. Each will yield results, and if you utilize a second photographer, that person could be dedicated to one spot for the ceremony.

This part of the ceremony was very special to the couple in question, and very rare within this church. In the balcony with a fast telephoto lens I was able to shoot with available light and tightly compose the photograph.

The safest, though probably the most ordinary, place to shoot, is front and centre from the main aisle of the church. This is a good location for the exchange of vows and rings (as the couple face each other), and as the couple kiss at the end. From here you can also do the photographs of the couple coming down the aisle. Don't neglect wide-angle photographs from this location. If you are close enough to the front, and the church is ornate, it can be a terrific shot.

A great second angle is from the side of the church facing the bride. She is the focal point of the event, and the day. If I can do it quietly, I will try to get around to the other side to photograph directly at the groom during his recitation of the vows (or the second shooter can do this). If the area is large and the ceremony short, I will usually opt for the angle facing the bride and hope for the best.

In this situation I used a wide-angle lens to show the scene and a very high ISO to work with the limited light. I could have used flash, but I find it is tough to put a delicate amount of light into a scene with a harsh source.

During the ceremony I try to find an angle that faces the bride, shown here speaking her vows. A telephoto zoom lens allowed me to frame from my position.

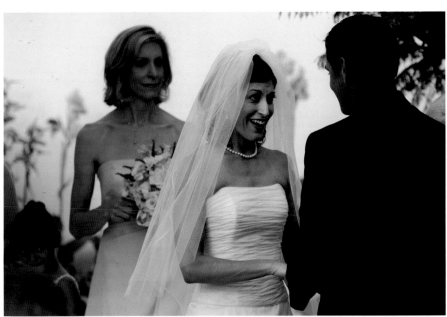

Don't be afraid to take advantage of your digital camera's flexibility here. Since you're able to switch the ISO at will, be sure that you've always got the most appropriate setting and make use of available light – it's more discreet.

My favourite angle, though, is directly behind the ceremony looking back to the couple and the crowd. It is important to clear this with the minister beforehand. You will probably need a telephoto to make this angle most effective. Be discreet when in this position. No unwanted attention should be on you. This works well in outdoor weddings, and not as well in older or smaller churches.

The fourth angle is in a church balcony overhead, which gives you a more expansive view of the church, and provides an especially nice view as the bride is coming into the church. It can also be an interesting angle when the couple are leaving the ceremony as well. This would be a great spot to dedicate a second shooter for arrival and departure shots.

When you are up front and on the sides, be careful to keep an eye on the parents and grandparents sitting in the assembly. Watch for their reactions and emotions.

The use of a fast (f2.8) 70–200 zoom or a fast prime lens (i.e. 135mm f2) can be useful in these situations. Often you cannot get too close so having a bit of reach with a telephoto can be helpful. I rarely need anything longer or heavier than 200mm though. I find that I can usually walk fairly close to the altar and use my short telephotos for these situations.

Again, it is imperative to be quiet and discreet during the ceremony. Respect the wishes of the church or the venue when it comes to the use of flash during the ceremony. If you cannot use flash, be sure to increase the ISO to 800 or even 1600 to freeze the action that you will be capturing with your telephoto lens.

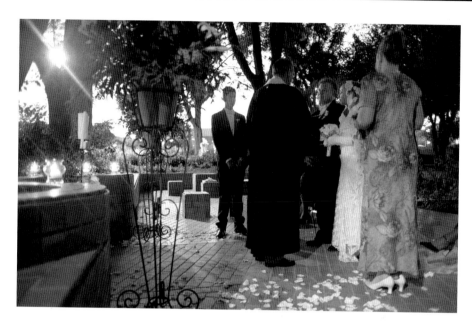

Using a moderate telephoto lens, I was able to capture a key moment in the couple's marriage ceremony mass. Using a high ISO (800) I was able to work quietly and discreetly.

After the ceremony, keep watching the couple. Moments after walking down the aisle, this couple came together at the back of the church with a great display of emotion.

TIP Before things start, take a test shot at a high ISO to check for graininess on the LCD.

Exchanging rings

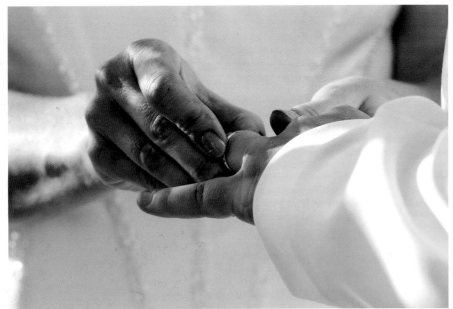

In this photograph I used a 70–200mm telephoto zoom lens right at the end of its range to get very close to the exchange, while keeping an appropriate distance from the ceremony.

Obviously, the closer I can work discreetly the better this photograph will be. With church weddings, it is often more difficult to achieve this tight shot without the use of a long telephoto lens. At other venues, I find the atmosphere is a bit less intense, so I might be able to get closer with a shorter telephoto zoom or fixed prime lens. Use your best judgment and sense with regard to appropriate distance. In some cultures, it is acceptable for the wedding photographer to be on the altar with the couple, shooting away with a wide angle lens. Personally, I prefer to stay back and shoot with moderate telephoto lenses to capture the event.

This is also a case where having two photographers shooting from different angles can be very helpful. If one is in the centre aisle, the other photographer could be behind the couple and shoot back. Again, having a zoom can be helpful as you can compose a tight photograph of the hand and ring, and then immediately back off to show the face of the bride looking at the groom as she places the ring on his finger. While possible, it might be more difficult to do that last sequence with prime lenses. Or you could try two cameras each with varying focal length lenses.

Still, it is a key shot to make and one to look for at every wedding.

A variation of the photograph above, this was also taken with a zoom at the long end of the range. The lighting was tricky since the actual ring exchange took place as both shade and sunlight hit the couple, but it adds to the look. More casual settings for a wedding will allow you to get a bit closer. Church weddings often require you to be further back, making this more difficult.

This is a photograph that I look for at every wedding, and it's always slightly different. I suppose one could always replicate the exchange after the ceremony, but that goes against my documentary roots. I also try to make each wedding unique and, while I show tight photographs of the ring exchange, duplicating the shot for every wedding would be neither fun nor practical.

Ensure that your focus is on your subject – the ring – since sharpening this object is harder to achieve digitally than applying a gentle *Unsharp Mask* to the rest of the image. You may need to override the autofocus.

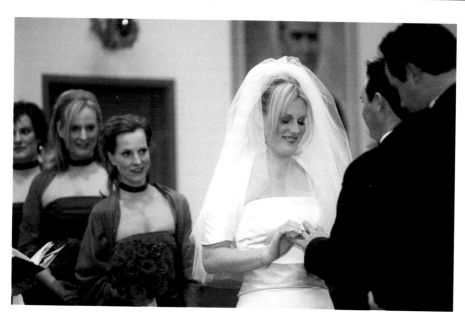

Shooting from further back (in a church) with a 135mm lens and with a subtle amount of on-camera fill flash, I was able to illuminate the bride as she placed the ring on the groom's hand. A high ISO (800) was used in addition to the flash fill.

Throughout the day keep an eye out for a photograph that illustrates the ring. Using a 50mm lens with digital and flash bounced off the floor, I was able to place some interesting light on the bride's hand as she danced with her husband.

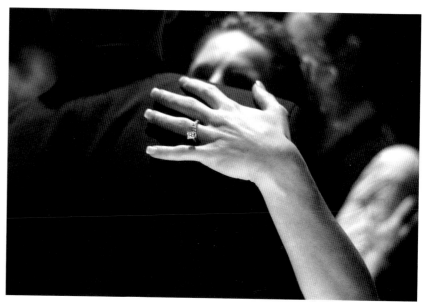

It's a good idea to take a ring shot just in case you are not able to get a great ring exchange photo from the ceremony.

Here I photographed with a 50mm lens on a digital camera, so that's close to 80mm in terms of the equivalent focal length.

TIP Should your subject's manicure be slightly imperfect, they will appreciate editing!

Speeches and toasts

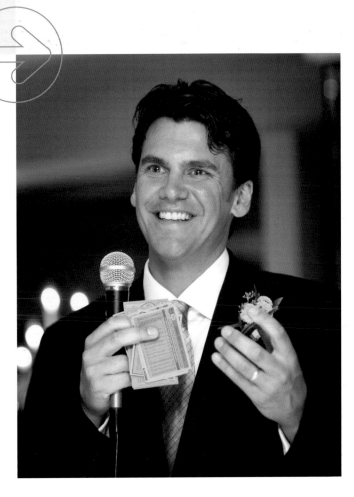

During his speech, the groom smiles as he shares special sports trading cards with the people who mean the most to him. Using a short telephoto lens, I was able to capture his natural expression and also to see the cards he gave to his friends.

Keep your eyes and ears open and be ready to capture the reactions to the speeches as seen here.

In any event, it is critical to the coverage of the day to get great photographs of everyone who is giving a speech, and a good few reaction shots too.

I find that a short telephoto, or telephoto zoom, is very useful for this shot. I have also been shooting this recently with a more normal lens (50mm in film, 35mm lens on a digital) and have been quite pleased with the results.

One of the things I look for is placement of the subject in relation to the background. If there is a chandelier or other warm light source, I will often use it to create a nice element in the background. I often shoot with a wide aperture, so anything in the background, even with a normal focal length lens, will tend to drift a little out of focus. With a short telephoto at a wider aperture, the depth of field will be minimal, and will allow you to key very successfully on the real subject of the shot – the speaker.

Watch that you keep the arm holding the glass in the frame during the toast. I have made the mistake in the past of shooting too tightly, and so missing or barely making a photograph showing the glass.

Speeches and toasts are traditional at weddings, especially in Britain, and will almost always be an important part of the day. The best man, especially, is almost contractually bound to raise a few smiles.

TIP
If you're shooting a friend's wedding, listen out for a mention in a story!

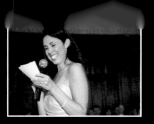

You can never quite be sure whether a speech will elicit raucous laughter or be greeted with an embarrassing silence. It is not a bad idea to consider your tactics for either outcome: reaction shots look better when the guests are reacting.

Once the toast has been made you should quickly turn to the bride and groom and shoot them as they toast their glasses. I will often watch them closely during the speeches because there are frequently stories and jokes told that will elicit many smiles and laughter. I like to shoot with a longer lens in these cases, but it depends on where they are in relation to the speaker. There might be a shot of the couple in the background, with the speaker out of focus in the foreground. In this case a long telephoto lens will isolate the couple and keep the speaker out of focus.

After the toast, I often look for the bridal party clinking glasses with the couple or other tables as they toast each other. Sometimes available light photos with blur at this time can be quite interesting. Experiment and try to do new things with this part of the day at each wedding.

 The father of the bride becomes emotional during his speech. *Standing back with a short telephoto lens and a wide aperture I was able to create* *narrow depth of field. Flash light was used to illuminate him.*

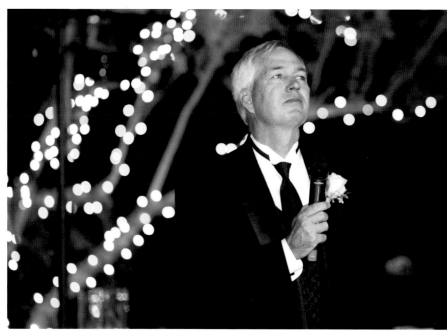

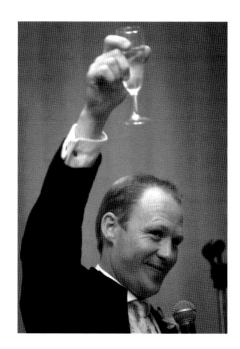 *As the groom raised his glass, a short telephoto lens allowed me to* *capture the action, and bounce flash (off the ceiling) helped illuminate the scene.*

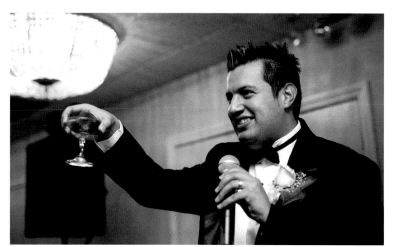

Using a normal length lens, I used flash bounced off the ceiling to *light the foreground with a slow shutter to let the background light show.*

Cutting the cake

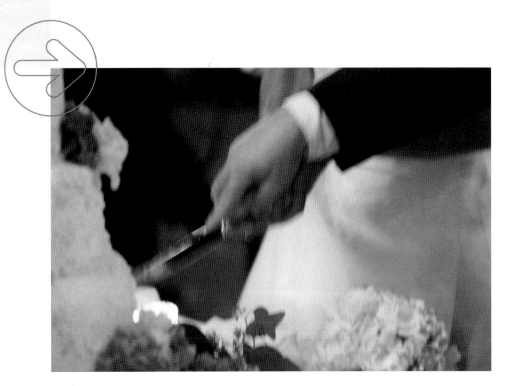

This is one of those expected and traditional photographs that can be great fun, and where each couple's unique personalities and dynamism should show through in the pictures.

It's wise to get an interesting photograph of the cake before the cutting, and often the best image is a detail photograph. This one was taken with a telephoto lens and bounce flash (off the ceiling at left).

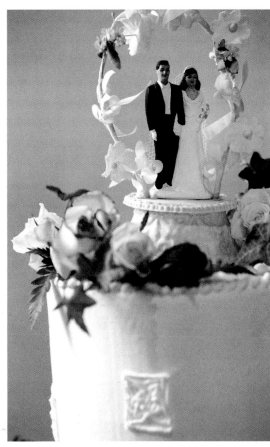

While I also captured the wider view of the cake cutting, my assistant shot this very tightly using available light. Due to the very low light, a slow shutter was necessary and the slight blur added to the effect. Black and white conversion and grain were added.

In the actual cutting the cake photograph, I really try to get the couple to find a place where they naturally feel comfortable. Direct very little – it's better if someone else instructs the couple because it lets you set up for the photo and brings less attention to you.

For the actual cake cutting shot, I endeavour to show the cake, the couple, and the cut all in one frame, and I really prefer if they don't look at me as they cut the cake. If I am working with an assistant, or if I can do it quickly, I will often have a tight telephoto shot of the hands on the knife as they cut the cake.

Be sure to get several photographs of the cake from various angles before the actual ceremonial cutting. Find out where the cake will be early on, and proceed to watch how the light affects it during the day. It's just one of those little details that people like.

After the cake is cut, the couple will proceed to feed each other cake. This is when you need to be ready. Many of the couples that I have photographed have been very gentle with each other as they feed the cake but you have to be ready in case you get a couple who are a bit more playful. In either case a normal focal length or a medium-range zoom (28–70mm) works well for this photograph.

To avoid the formality of poses, I ask the couple to just go ahead, and not to mind me. Most of them have a good sense that I document their day in a very natural way, and by this time they are comfortable with me and hopefully relaxed and happy.

After the cake is cut, I often look for a shot that shows the cake with the slice removed. If I can capture that in an artistic way, then I feel I have succeeded. I still look for that great shot that shows the cake and the couple in the background naturally.

The cake is important to a lot of people, so it's worth asking the catering manager or organizer whether it has any special details you should photograph before the cutting. As for the moment itself, be prepared for anything.

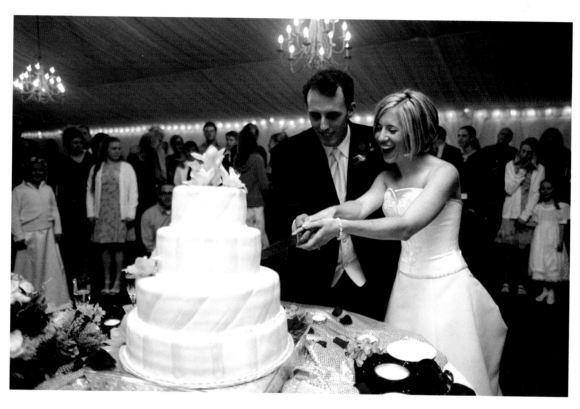

As friends and family gather, the bride and groom perform the traditional cake cutting. Using a slow shutter speed to capture the ambient light, I used flash bounced off the marquee to illuminate the foreground.

Using a normal focal length lens and bouncing the flash off the ceiling I was able to get natural-looking light as the couple feed each other. This can often make a terrific sequence in the final album. Be ready to fire several photographs as the feeding proceeds.

Continuing to shoot allows me to capture a lively reaction to the cake feeding.

TIP This is potentially one of those occasions when you'll need to know your burst limit.

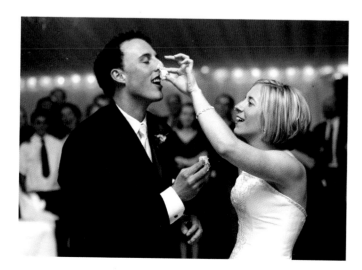

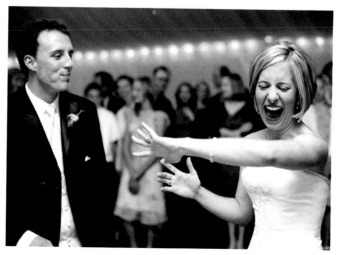

The first dance

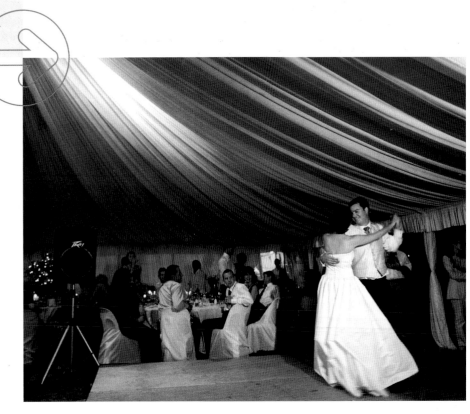

Sometimes the best lens for the dance photograph is a wide-angle (here a 28mm efl), giving the photograph a strong sense of place. This was originally photographed in colour. I converted it to black and white to emphasize the dramatic lines from the marquee.

This just might be my favourite part of the day. I love the emotion and the action of the first dance. In addition, it really gives the photographer the opportunity to make something of a spectacular venue.

This is another one of those key moments that must be recorded from every wedding. Shoot heavily here because this one is one where you have to score a great photo.

I will stay back and often shoot this photo with a short telephoto zoom or short prime lens because I want to capture the expressions between the couple. One reason I do this is because I try not to get too close to the couple during this moment. This is where a short telephoto can come in quite handy. I will also get low, often dropping to my knees, and shoot with a wider angle lens to show the couple as well as incorporating a feel for the room. If there is dramatic lighting or chandeliers, they help make the image even more compelling.

With regard to lighting, I might use the ceiling to bounce the flash if it is not too high, or take some shots with available light, again to avoid affecting the mood. It's a good idea to take some shots with the strobe to cover yourself. At other times couples will be lit with lighting equipment from the entertainers or the DJ. If it is there, use it. Move around and experiment. Don't be afraid to shoot more than

This image is remarkably true to the available light (a blue spotlight provided by the DJ) during the first dance. Plus, by using a fast 28mm lens I was able to avoid using flash (though I took some with in case it didn't work).

you might shoot for other events. This is a big one and requires more attention.

If there is a videographer present, enlist them in a strategy to cover the event. Try to accommodate their needs, but get them to recognize yours as well. If you know the couple will take a dip at the end of the dance,

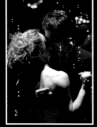
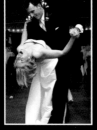

When taking images of the first dance, remember that while you are striving to capture the moment you might also be looking for some images that can be digitally manipulated, perhaps to exaggerate the couple's presence.

TIP A videographer may have an on-camera light. Make use of the effect in your shots.

 Actually this was the couple's send-off dance, but it shows the power of moody light and a fast prime lens (a 50mm f1.8 lens). I was able to keep detail in the highlights and pull up the midtones and shadows using a digital burn and dodge. Using flash would have totally destroyed the mood.

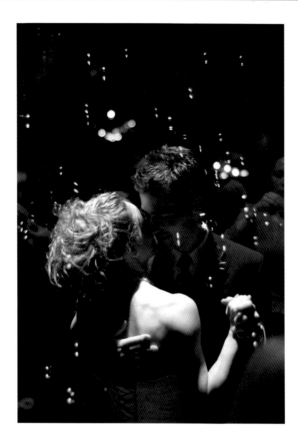

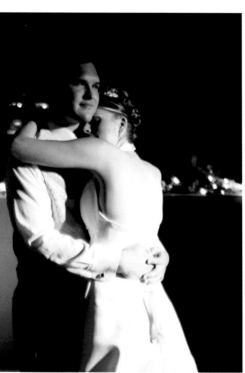

 The bride's mother (right) is comforted by a family friend (left) during the bride's dance with her father. Using a flash bounced into the ceiling, I was able to create a soft, natural light that reproduces nicely and looks real. Being aware of what is going on around you allows you to capture a gentle moment such as this.

be ready for it. Often, many couples will take dancing lessons to really shine on the floor. If you know that, you can be ready for a special moment. The best way to have that light look dramatic is by keeping it to the side or using it as back-light. Look for drama and tender emotion during this dance.

Keep an eye on the reactions of the crowd, especially the bride's parents, and more specifically her father. At the end of the dance, watch for the crowd's reaction to the couple and look for hugs, applause, or celebration. Get a sense for the mood of the crowd and respond to those emotions.

The send-off

At a London wedding, I followed the couple as they said goodbye to friends during the send-off. Using a 16–35mm lens and flash bounced off the ceiling (plus a slow shutter to capture more ambient room light) created a flattering broad light source.

The tradition of the send-off seems to vary from place to place. In Britain in particular, it's often a big event with all of the guests waving goodbye. Alternatively the 'moment' might be on leaving the church – I have witnessed couples cheered by family and friends as they walk through hundreds of bubbles.

If the couple casually say goodbye to their friends at the end of the reception, I look for intimate wide-angle shots of the couple as they meet their friends. I try to just be a fly-on-the-wall and document the moment. I find that with a moderate wide-angle or a normal focal length lens, I can capture telling images that showcase a bit of the location.

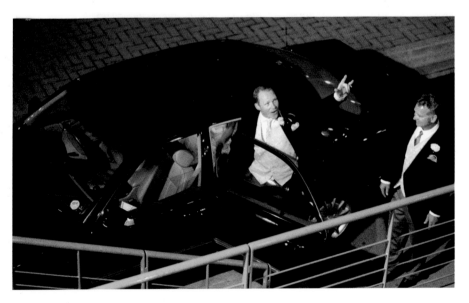

As the bride and groom leave in a limo, the best man stands down by the car. Shooting from the balcony with a fast lens and a high ISO allowed me to capture this with available light.

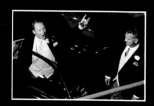

If you know you're at a wedding without a ceremonial send-off, don't be afraid of asking when the couple are planning on leaving so you can pick up some shots like these. If necessary, keep your eyes on them towards the end of the evening.

Staying until the end allows you to capture moments such as this, of the groom hugging his sister before leaving the reception.

Lit only by the lights of the couple's car, friends take photographs as the couple leave the reception.

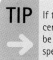

TIP If there is no ceremonial send-off, be discreet. These are special moments.

Throwing the bouquet

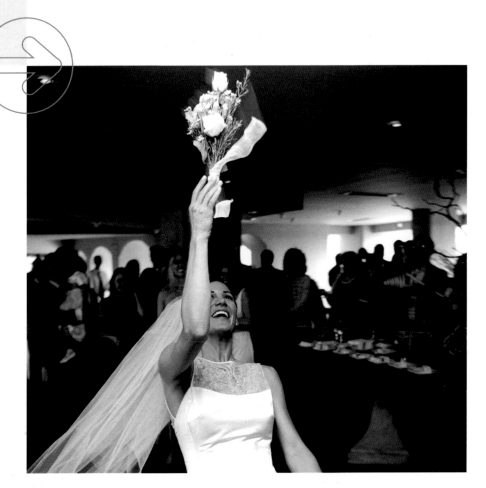

Timing is everything when it comes to the throwing of the bouquet and garter. Using a moderate wide-angle lens, and flash bounced off the ceiling, I was able to capture the bouquet just after it was thrown.

I like to stand in front of the bride, and sometimes on a chair, in order to get a higher angle to see the women in the background. I shoot a few photographs as the bride warms up.

If you have a second photographer, that person can be stationed a bit off to the side and with a lens that will allow them to capture more of the action as the single women make their mad scramble for the bouquet. The combination of the photo of the bride mixed with the action of the scrum can be quite nice in the album.

If you are by yourself, however, you might want to stay on the ground and not the chair to capture the bride from the front, and slightly off centre, as she throws the bouquet. This alternative angle will give you a chance to have a good, clean photograph of the fight for the bouquet.

This is where you need the timing of a sports photographer to capture the perfect moment: the release of the bouquet. This is potentially problematic on digital cameras, as it's easy to be caught out by the shutter lag.

Jubilant, the groom's sister raises the coveted bouquet overhead after catching it.

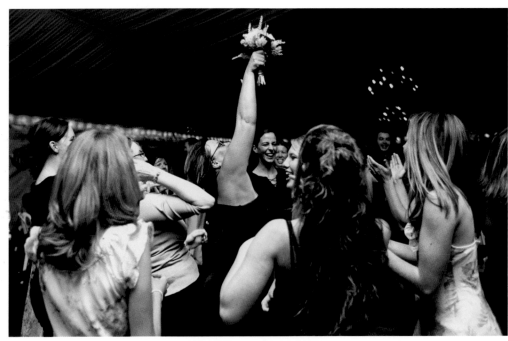

This is another area where digital can provide some help, but perhaps not as much as you'd hope. Though *Motion Blur* can be added, it tends to work in a more linear, less human fashion, even if carefully added using Photoshop layers.

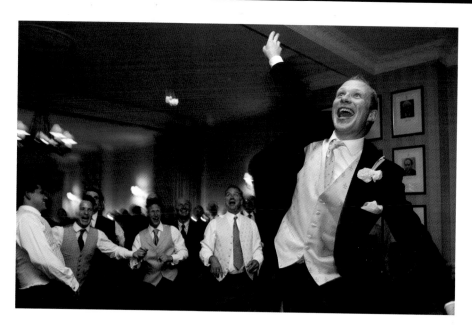

In this instance a wide angle to short telephoto zoom (24–70) can be very useful. Or use a wide angle on the one camera for the shot of the bride throwing, and then a normal focal length to capture the fray after the throw. Using a flash for both is a safe bet because the light might be too low to stop action using just available light.

If the groom removes the garter and throws that, you can work very similarly to document that too. I always try to get a photograph of the two winners of the bouquet and garter together showing off their prizes.

The groom lobs the garter over his shoulder. Working from ground-level with a moderate wide-angle lens and flash, I was able to time the shot to catch the garter in flight.

I had to be very precise about shooting since there was really only one chance here.

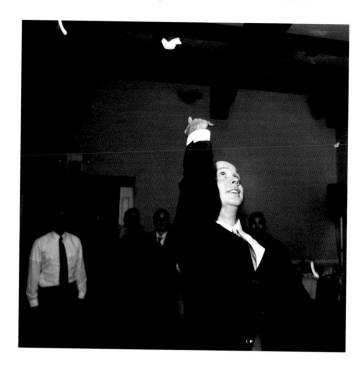

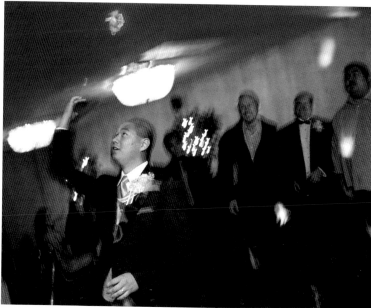

This photograph was captured with a moderate wide-angle lens, on-camera flash and a relatively slow shutter speed (in order to capture some of the ambient light as well).

5 Digital darkroom techniques

The capabilities of the digital camera and its
processing power are just the beginning of the digital
revolution. Relatively inexpensive computer technology
can now take images through the next steps, allowing
a virtually limitless degree of enhancement and
manipulation before printing. All this, too, from the
comfort of a fully lit room, without a jar of chemical
fixer in sight. This chapter is about using these tools
to hone your digital images.

Image-editing software

A Levels *adjustment layer was created to begin working on this photograph. These are methods of altering the tones of images which can be adjusted on a new layer without losing original data.*

Curves *are an alternative way to adjust the tonal distribution of the image. There is a lot of choice in the major software.*

As far as most wedding photographers are concerned, there is one standard for image-editing: Adobe Photoshop. There are certainly other applications on the market, such as Paint Shop Pro, that are used by photographers, but Photoshop is unquestionably the most popular and widely used.

Photoshop allows the user to create albums, individual prints, crop, resize, optimize colour, dust spot and retouch, turn colour photos into black and white, sepia- or selenium-toned images – given enough time you can achieve virtually anything.

Some photographers create masterful montages using multiple layers, other photographers use Photoshop as a glorified darkroom. I can only surmise, but I have no doubt that the masters such as Ansel Adams and W. Eugene Smith would have quickly and readily adopted Photoshop. They would have loved the ability to create the image they saw in their mind right from the desktop.

The power of Photoshop is in the power of layer masks. Learn how to use them and you will be able to go back over your work, edit it, tweak, and revise it. Layers also create massive Photoshop files so it is critical to have both large amounts of memory in your computer, and plenty of storage for the images.

Image management is an ongoing issue as more and more digital images are shot and then archived. Having a system in place can save hours of work and aid your business by being able to find images quickly for clients and vendors.

Regardless of whether you are using film scans or digital capture, Photoshop will have an impact on your working life. It will become imperative to have a fast way to digitize images because of the competitive nature of the marketplace. In an industry where speed was never considered a factor, it is now a top priority.

Couples now, more than ever, want to see their wedding images as soon as they can. Let's face it: we have become spoiled by the immediate rewards of digital cameras as they become ubiquitous. I rarely see a film camera at the weddings I document; so prevalent is the switch to digital among not only my peers, but amongst all the wedding guests with their compact cameras too.

TIP → Before buying an application, try it out: most vendors offer 30-day trial versions.

If you are working on a budget, Photoshop Elements is a more than adequate substitute for Photoshop. Although it lacks some of Photoshop CS's advanced features, the editing tools are remarkably similar.

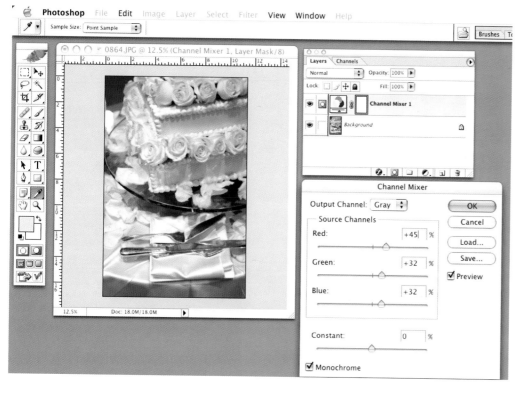

Photoshop and its ilk give you the ability to change colour images to monochrome by several means as well as numerous other effects.

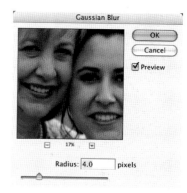

KEY POINTS OF IMAGE-EDITING

First open the image in Photoshop, whether it is from a film scan or shot digitally.

To do this you need to go to *File > Open* or you can take your image from the CD and drag it to your Photoshop icon. Make sure you are working in the proper colour space for the type of output you will be producing (for professional work, printed on high-quality, four-colour press, you would usually want to work in the Adobe 98 space; for images that will be output to photographic printers such as the Fuji Frontier, or even output to inkjet printers, you would most likely want to work in sRGB).

Secondly, create a copy of that layer either by going to *Layer > Duplicate Layer* or *Layer > New > Layer via Copy* (Cmd+J). I strongly suggest learning as many quick keys as possible, and committing your favourite Photoshop moves or actions to quick keys. This will save you a lot of unnecessary mousing.

Third, use *Levels* (or *Curves*) to adjust the overall colour and contrast of the image. Be careful to maintain highlight information when shooting, and realize that digital capture has a narrower dynamic range than film. Concentrate on creating pleasing flesh tones for your clients.

You can create blur layers that help flatter subjects, or to draw attention away from certain parts of the image. Create a separate layer when doing this.

Size your document for the intended usage (or save the tweaked file at maximum resolution so you can save a copy of the scaled down version for output later).

The final step after all your tweaking and resizing is to sharpen the image.

I suggest saving your tweaked files in the PSD format with your layers intact. This way if you need to eliminate a photograph from a layout or change a colour slightly, it is relatively quick and easy to do.

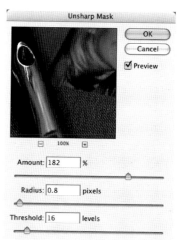

You can also apply 'filters' to your images, in this case the Unsharp Mask, *a method of sharpening.*

Another filter, the Gaussian Blur, *is invaluable when creating focus effects, even just to areas of the image.*

Rotating and straightening

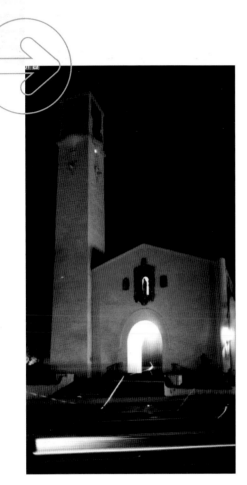

A ngle and perspective have always been problematic for photographers, since lenses can introduce aberrations or converging verticals. First things first, this, as well as basic rotation, needs to be sorted out.

ORIENTATION

To flip a horizontal photograph and make it vertical, you need to go to *Image > Rotate Canvas > 90° CW*. This will be useful because digital cameras generally capture with a landscape orientation and portraits will have to be rotated once brought into your image-editing software.

PERSPECTIVE

Skewed perspective can appear when you shoot with a wide-angle lens and tilt it up as you photograph a building, for example. Fortunately, with software such as Photoshop you are able to correct those distortions. As with this church shot (the final shot is on the left) it's best to minimize, but not eliminate, this effect.

TIP Some cameras can automatically detect orientation, but not all software notices.

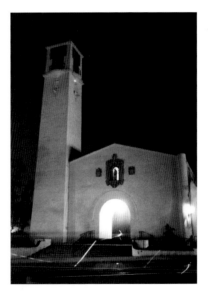

1 This shot with a wide-angle lens tilted up created a keystone effect on the church. To correct select the *Crop* tool from the Photoshop Toolbox.

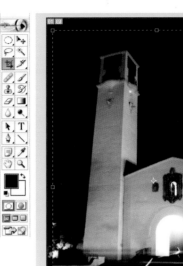

2 First make a rectangular selection around the subject, as you would if you were simply cropping the image to a new shape. The *Tool Options Bar* then changes. Check the *Perspective* option to the right-hand end of the options available. We are now able to move the corners of the rectangle individually to create a skewed shape, which will still be rectangular once we make the crop.

3 Make adjustments by eye to mimic the angles in the subject (going too far looks unnatural). Finish with the tick in the *Options Bar*.

Even the most careful of photographers will sometimes end up getting a shot where the camera wasn't at the right angle. So long as you don't mind cropping a little, that can all be put right in a very few clicks.

ROTATING

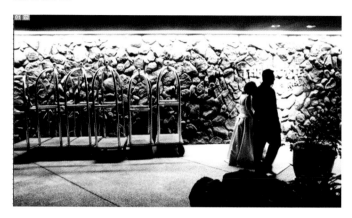

If you happen to shoot a photograph that is slightly tipped due to operator error, it is very easy to crop and then do an arbitrary rotation of that image.

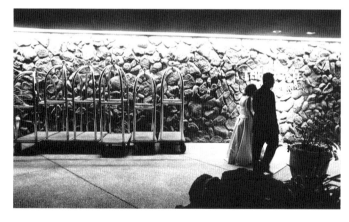

1 This is the original scan from the photograph. In my haste to capture the moment, I didn't frame in such a way as to keep the top line straight.

2 The *Measure* tool, usually below the *Eyedropper* in the Toolbox, will help us correct the skewed frame very quickly.

3 Click at one end of the edge you want to correct and release at a point at the other end. Measurements appear on-screen.

Mode
Adjustments
Duplicate...
Apply Image...
Calculations...
Image Size...
Canvas Size...
Pixel Aspect Ratio
Rotate Canvas ▶
Crop
Trim...
Reveal All
Trap...

180°
90° CW
90° CCW
Arbitrary...

Flip Canvas Horizontal

4 Click on the option *Image > Rotate Canvas > Arbitrary*.

5 Photoshop copies the exact amount of rotation from the *Measure* tool. Click *OK*.

Rotate Canvas

Angle: 1.78 ○ °CW ● °CCW OK Cancel

6 Once rotated, the photo is then shifted on the canvas in Photoshop.

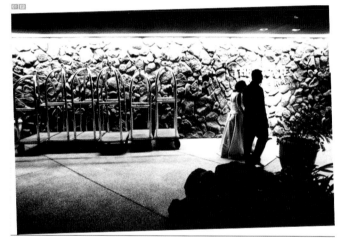

7 Using the *Crop* tool you can then crop around the part of the image now that it is straight, and lose the border.

Cropping and sharpening

In an ideal world, you would never have to crop your image, and every photograph you take would be perfect. Sadly the world isn't perfect, and, despite what many purists say, cropping is a very useful option for the photographer. Because weddings are fast-moving events, it is not always easy to get the perfect crop in camera. Also, a special crop (such as a panorama or square) might enhance the overall look and impact of a certain photograph or presentation.

TIP Check that previous settings haven't been left in the *Crop* tool's *Options Bar*.

CROPPING

Cropping for impact brings the viewer directly into the expressions and moment of the scene. It can also let you change the format of the frame.

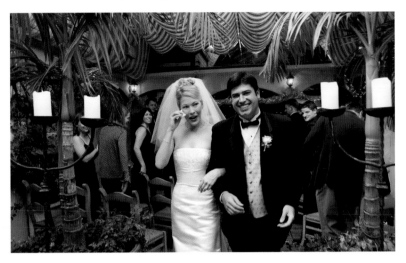

1 A wide view of the couple leaving the ceremony, and while I like this view, I can make a case for a strong crop of the couple as seen left. Being able to crop gives you the ability to get the most emotion out of the photograph.

2 The crop marks are indicated and a large portion of the photograph is cropped. To crop you need to select the *Crop* tool in the Toolbox. Click, hold, and drag the mouse over the area that you want to preserve. If you know exactly how big you want the image to be, you can select the dimensions you want. I prefer to do the crop and then resize later, but that is a personal preference.

:k your camera's
u for any
pening option
ss it is RAW).

SHARPENING

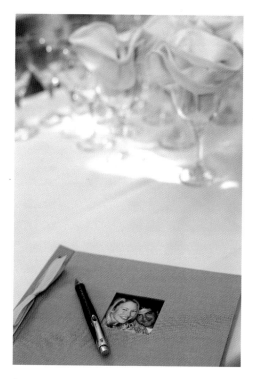

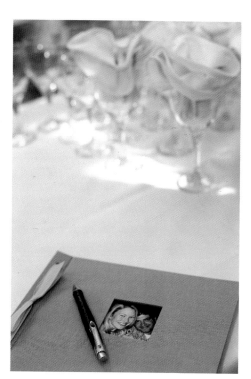

Sharpening is a very useful tool in the Photoshop arsenal, and is particularly helpful with images that have been scanned or might need a little help to look sharper.

1 This photograph, shot close to maximum aperture, has a very narrow area of focus and the *Unsharp Mask* filter might be useful to help emphasize that sharp area.

Filter | View | Window | Help
Last Filter ⌘F

Extract... ⌥⌘X
Filter Gallery...
Liquify... ⇧⌘X
Pattern Maker... ⌥⇧⌘X

Artistic ▶
Blur ▶
Brush Strokes ▶
Distort ▶
Noise ▶
Pixelate ▶
Render ▶
Sharpen ▶
Sketch ▶
Stylize ▶
Texture ▶
Video ▶
Other ▶

Digimarc ▶

Sharpen
Sharpen Edges
Sharpen More
Unsharp Mask...

2 Click *Filter > Sharpen > Unsharp Mask* and adjust as you like.

Unsharp Mask

OK
Cancel
☑ Preview

⊟ 100% ⊞

Amount: 182 %

Radius: 0.8 pixels

Threshold: 16 levels

3 Click *OK* to apply the settings. This should be the last step before photos are output.

Unsharp Mask
The USM is made of three different parts:
AMOUNT The higher the number, the great the effect will be. Adobe recommends this to be set at 150–200 for high-resolution printed images.
RADIUS Controls the distribution of the sharpening effect. Adobe recommends a setting here of 1–2 for high-resolution images.
THRESHOLD Which pixels will be sharpened based on how much they differ from the brightness of their neighbouring pixel. Adobe recommends a setting between 2 and 20 for images with flesh tones to avoid introducing noise. Talk to your lab professional as well.
Certain machines at your lab may place an unsharp mask on your image file before printing. Therefore it is important to know whether you need to do likewise, or whether you can request that no sharpening be applied to your prints.

Fixing over- and underexposure

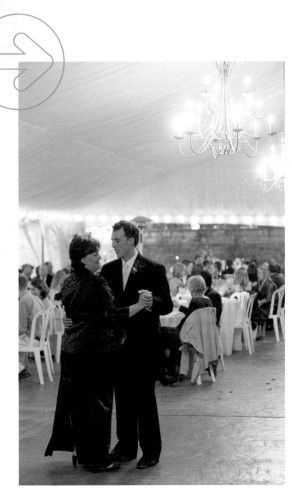

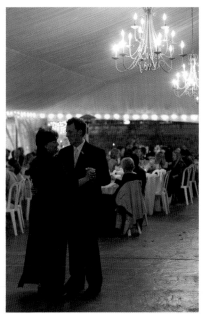

2 I created a *Curves* adjustment layer to open the shadows without doing anything to the main image. Work on a copy of the original with adjustment layers – it is the safest way to work in Photoshop.

1 Here is the file as captured at 800 ISO on a Canon 10d.

Digital cameras are good, and getting better, but they are not perfect. And in the hectic world of wedding photography, sometimes we make bad exposures. With digital, exposure is even more critical than with colour negative film with all 11 stops of latitude.

UNDEREXPOSURE

Some digital photographers deliberately underexpose their shots by around half a stop, simply to avoid blowing highlights. Photoshop can convert them all as a batch when uploaded, but loss of detail through overexposure is much harder to rectify in digital, especially in JPEG work.

An advantage to digital is the ability to check quickly that your histogram is properly exposed to eliminate overexposure. Some cameras have a handy warning light that blinks when highlights are blown.

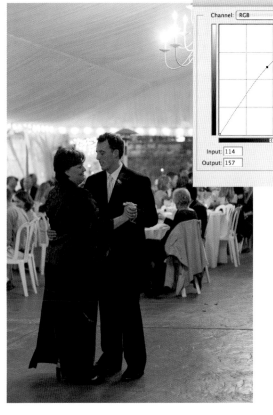

3 Pulling in a gentle arc from the centre I was able to see more of the image in the shadows. To really add finesse I would have to create a layer mask on this adjustment layer and paint back the detail in the lights. This is a bit involved, but a very useful option (*see page 123*).

DIGITAL DARKROOM TECHNIQUES

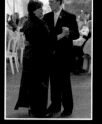

If you are working wih the RAW format, over- and underexposure is less significant, since you can alter the exposure by one to two stops later, but even then digital cameras are prone to blowing highlights.

TIP You may also want to work on small areas of an image, using the *Dodge* and *Burn* tools.

OVEREXPOSURE

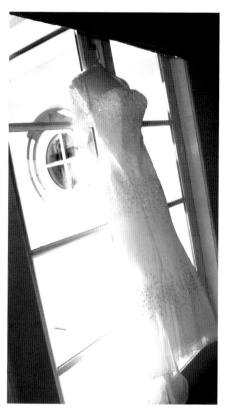

Fixing overexposure is a bit more difficult. It is virtually impossible to put information back where none exists. So be very careful not to overexpose your images.

Flash fill is a good way to handle the limited contrast range of most digital cameras. Adjust the settings so that you get just enough light to fill the area and not too much to overpower. Of course, you can adjust to taste.

Back-lighting is also tricky for digital. In most cases, your best bet is to expose for the tones that you must hold detail in and then use fill-flash for the foreground.

TIP Consider Photoshop's *Image > Adjustments > Shadows/Highlights* tool (new in CS).

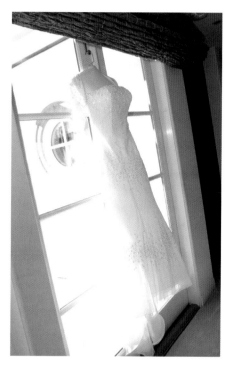

1 This is a bracketed photograph of the wedding dress that was overexposed in the background. It's probably beyond saving, but we'll try. I have darkened versions of this from the original shoot, but we'll use this frame that is blown out.

2 Create a new *Curves* adjustment layer as shown.

3 Pulling the curves line gently from the centre pulled down the values, but the highlights are so far gone that I decide to convert to black and white and utilize the extreme tonal scale. Since I know I'm converting to black and white, I forgo doing any colour correction to the image.

FACT FILE

Curves

The 'curve' in question is a line representing *Input* tones, the original image, and *Output* tones, the shades to which the input tones are adjusted by the tool. By moving points and altering the curve, you alter the *Output* tones. If, for example, your curve dips as above, then midtones will be darkened more than the others.

Dodging and burning

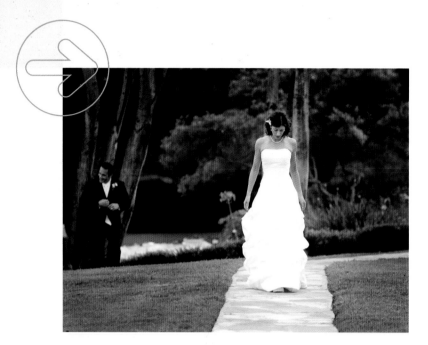

When you dodge and burn with Photoshop you really begin to see the power of the program. In the old days you might use a dodging 'wand' or a hole cut in cardboard to do a burn of a selective area.

BURNING
Burning in Photoshop, however, gives you adjustable brush sizes, adjustable 'exposure' and, of course, multiple levels of undo and redo, which you really don't get in the lab.

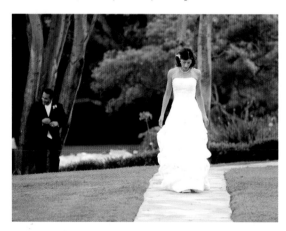

1 Here's our starting image that has been cropped and colour corrected before doing the burn.

2 Start by creating a new layer to work on.

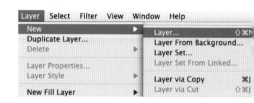

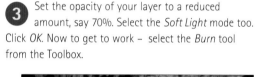

3 Set the opacity of your layer to a reduced amount, say 70%. Select the *Soft Light* mode too. Click *OK*. Now to get to work – select the *Burn* tool from the Toolbox.

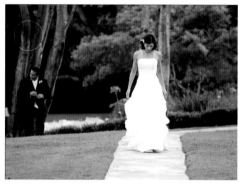

4 Click and paint with the *Burn* tool in the layer mask. The beauty of using layer masks is that you can always start again without doing any harm to your original image.

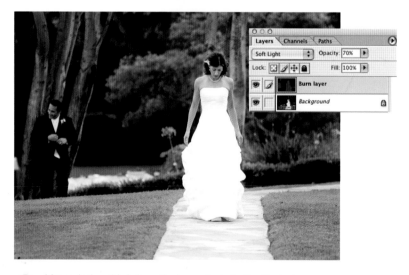

5 After painting this is how the image looks in the Photoshop window. Notice the way the brush affected the layer.

By altering specific areas of your image, you can tone down distractions or highlight the subjects. Digital takes this from a delicate darkroom craft into a possibility for the mainstream. Use it, but do so subtly; don't abandon reality.

Burning is used again here, after a colour correction, to darken the area of far-background at the top of the picture, so that it serves as less of a distraction. Dodging works in much the same way as burning. Indeed the *Dodge* and *Burn* tools are accessed from the same button in the Photoshop Toolbox.

2 The feature is only found in Photoshop CS and later. Click *Image > Adjustments > Shadow/Highlight* to open the dialog (and *Show More Options* at the bottom).

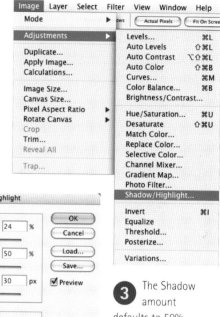

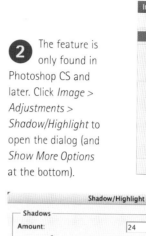

3 The Shadow amount defaults to 50%, so I cut back by half to make the dodge a bit gentler.

4 A vast improvement (though it would still need more tweaks) but this opened up the shadow area of the entire scene.

1 A powerful ally to *Dodge* and *Burn* is the *Shadow/Highlight* tool, which allows you to make global changes to images.

TIP Dodging and burning change the pixel values, so make a duplicate layer.

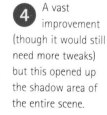

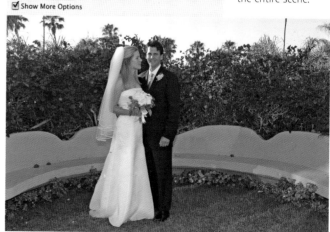

Optimizing tonal range and colour

Since we have already established that this histogram is a good way of checking for exposure problems, it follows that changing the histogram will go a long way towards fixing them. And that is exactly how the *Levels* tool works.

1 This detail photograph was captured by available light in a mixed light environment, and was unintentionally underexposed. I will use the *Levels* tool in Photoshop to begin to bring back as much of the exposure as possible.

THE LEVELS TOOL

The first thing you notice about the tool is that it looks, in many cases, like a mountain range. The 'mountains' represent large amounts of the shades beneath – a spike at the left-hand end represents a large number of dark pixels (shadows), lighter ones (highlights) to the right. This much we understand from the histogram.

But while the histogram is feedback, here we can make changes. There are sliders beneath the histogram which we can drag. In doing so, we move shades to make a new histogram.

2 Go to *Image > Adjustment > Levels* to get to the dialog.

3 Notice the amount of information compressed on the far left of the *Levels* window, giving me a graphical representation of a severely underexposed image.

4 Kevin Kubota, the Photoshop guru, would call this moving the mountains, for example taking the far right highlight slider and moving it to the beginning of the 'mountain range' of the *Levels* dialog box. Notice how the image immediately brightens up and moves into a useable range. This is still not optimum because so much of the information is compressed into the shadow side, but using this method of artificially stretching that data, even an image like this can be salvaged.

All that remains is a black and white conversion and, used small, this will still appear in the album.

The *Levels* tool is one of the most useful image adjustments available to the photographer, and mercifully easy to understand once you've got the concept of the histogram under your belt.

TIP You can make non-destructive changes using a *Levels* adjustment layer.

ICING ON THE CAKE

Colour balance issues are still tricky (and subjective) with digital. This is where it pays to know your camera and its colour balance quirks. If you can set a custom white balance or use the appropriate colour balance when you're working, do so. If you capture in RAW, you have greater options in post-production. Many working this way will capture in auto white balance and then tweak in the RAW converter. Either way, taking a few moments to set the appropriate colour balance can greatly reduce your time in post-production.

4 After running *Auto Colour*, run a *Levels* adjustment by going to *Image > Adjustment > Levels*.

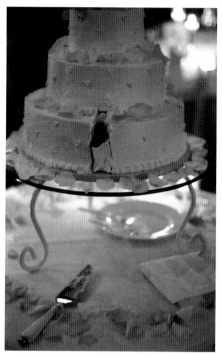

2 Work on a duplicate or an adjustment layer, which allows you to easily correct a mistake and so protect the original image in case you need to go back to it.

3 A new feature of Photoshop CS is the *Auto Colour* function. This command gets us into the game in terms of the colour, but we still need to tweak the file once *Auto Color* is executed.

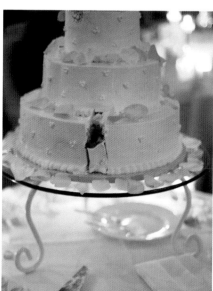

1 This is the original file of the cake at a wedding. The very warm tungsten lighting creates a warm photograph. While this colour might be all right for some, others prefer a more neutral colour balance.

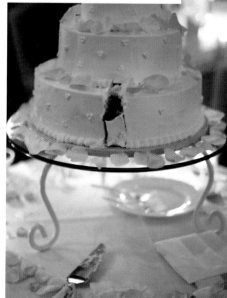

5 Since the image was underexposed, I moved the highlight value left to the 'mountains', and also moved the shadow value closer to the middle. I balanced this by eye by moving the midtones slider too.

Removing colour casts

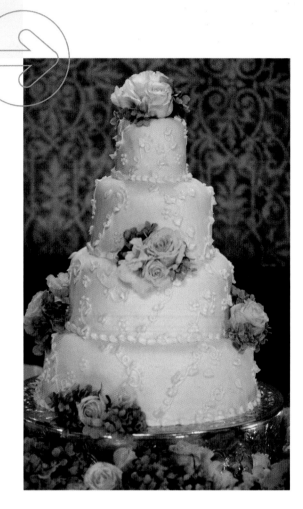

Sometimes we get caught up in the moment of the wedding day and forget to change our camera's colour balance moving from daylight to inside. Or, the camera's auto white balance simply gets it wrong. Removing colour casts is a fact of life in digital photography, and this can be achieved within Photoshop.

TIP → If you find yourself doing this a lot, consider a plug-in like iCorrect or EditLab.

1 This photograph of the wedding cake was taken in strong tungsten lighting so the overall cast of the image is far too warm. The photograph was also underexposed because the meter was fooled by the amount of white in the majority of the image. In order to get to this starting point, I used *Curves* to adjust the overall lighting of the image in the middle values (but did no colour correction).

2 First, choose the *Colour Picker* tool under the *Eyedropper* on the toolbar.

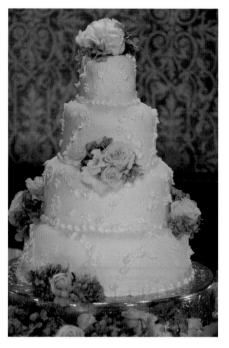

3 Find a neutral area, yet an area that is not totally white (you want to hold detail) and click. The *Colour Picker* marks that with a 1.

4 In the *Layers* palette, create a *Levels* adjustment layer (the circular icon, half black, half white, shows the adjustment layers).

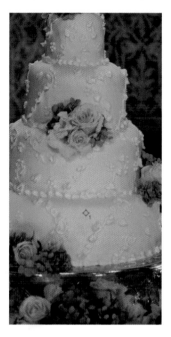

5 Double-click on the *White Point* eyedropper in the *Levels* dialog box.

If your camera, and software, supports RAW mode, then you are at an advantage making this kind of correction. The subtle extra information means that you run less risk of your restored image looking grainy.

TIP An alternative tool for removing casts is *Image > Adjustments > Colour balance*.

8 Replace the numbers in *a* and *b* with 0 (zero). Notice the change in the RGB values after doing that – they are all neutral. Click *OK*.

6 A new dialog box – the *Colour Picker* – appears after double-clicking. In this screen grab, it does not show up, but place the *Eyedropper* (with the *Colour Picker* window appearing) on top of the first colour sampled (1) and click.

9 The *Colour Picker* disappears, and in the *Levels* box, click on the white point dropper (lower side, far right, greyed out). Take the *Eyedropper* back to the original point 1 with precision and click on it once you are there.

10 This is quite a good recovery from a file that was pretty far gone. I added another *Levels* adjustment layer to lighten the image and boost contrast a tad in the final image (top left, facing opposite).

7 After clicking with the *Eyedropper* while in the *Colour Picker* window, notice the values that appear in L a b. These numbers are our concern.

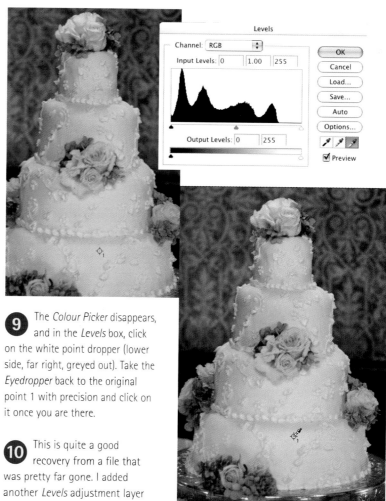

Soft-focus effects

Why create these looks? Quite aside from their being easier to achieve with digital, and your not having to risk using filters at the time of shooting, the looks are often popular. Also, these techniques can correct for flaws in the scene such as a cluttered or busy background. Purists may tell you not to alter reality – but all things in moderation.

1 A portrait of mother and daughter shot on 35mm film and scanned is a sweet moment of the two together. The grain is noticeable, though, and so I wanted to create a slight diffusion filter.

2 Duplicate the background layer by going to the *Layer > Duplicate Layer* command.

3 *Go to Filter > Blur > Gaussian Blur* to create an overall blur on this second layer. Here I have set the radius at 4, but anything between 3 and 6 is fine depending on resolution.

4 In that layer with the *Gaussian Blur*, reduce the opacity to 50%, which creates a very soft, glamorous glow in the layer.

5 Using the *Eraser* tool with a small soft brush, I went in and erased the blur layer around the eyes and mouth, areas that we expect to see as sharp. Your tastes, or those of the client, may dictate the amount of blur (and also sharpness) in the image.

Digital provides a huge advantage in this area of photography. In the past the shots taken with tilt-lenses or double exposures were final. Here you have the option, or not, to apply this effect to any of your compositions.

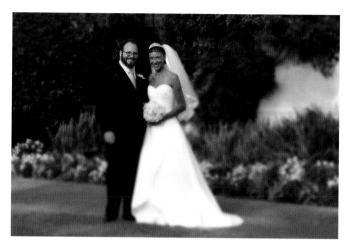

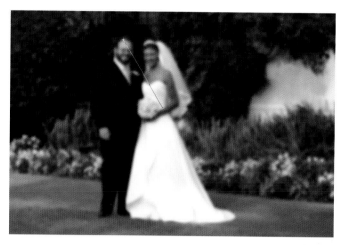

Another soft-focus effect is the digital equivalent of a limited depth of field. This is one of a number of ways to achieve it.

4 Using the *Gradient* tool, drag a line as shown to create a layer of sharpness amidst the blur.

1 Here's a portrait of a couple, and while it's well exposed, for purposes of this illustration, I want to create the look of an artificially reduced depth of field. The aim is to create a bit more impact and draw more attention to the couple.

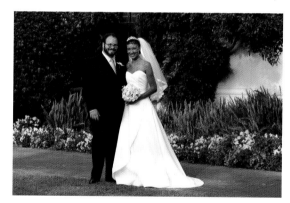

5 Notice the effect the radial blur with the *Gradient* tool had on the layer mask, and how that translated to the image itself. You can move the gradient tool in different directions to see the effect.

2 Create a duplicate layer as in the first example. Add a *Gaussian Blur* to that newly created layer. I wanted a more extreme blur in this photograph so I set the radius to ten.

6 I wanted to make the upper left background out of focus again, so using the *Brush* tool (white colour), I painted on the layer mask to make that area blurry. Using the *Brush* tool with black paint on the layer mask makes that part of the mask sharp.

3 Create a layer mask on the blurred layer and click on it with your mouse to activate it.

Retouching like an expert

Photoshop gives you all the tools of the finest Hollywood retoucher. With this software you can literally take years off your subjects. The challenge, though, is keeping the work believable and understated. And while you can use Photoshop to be a bit of a digital plastic surgeon, you may want to rein in the effects to keep it believable.

RED-EYE

1 Photographing with a 200mm lens and on-camera flash, I still got red-eye on the bridesmaid and her escort during the procession at a wedding after sunset. Zoom in and select the *Color Replacement* tool.

2 Ensure the *Foreground Color* is the colour you want the eyes to be, and click with the centre of the pointer over the colour you'd like to replace. It will be substituted with an appropriate shade of the selected colour.

EYES

1 If we wanted to, we could change this lovely green-eyed bride to a blue-eyed bride (just for the purposes of this book). I selected a blue colour from the *Color Picker* and selected the *Color Replacement* tool. Be sure to create a separate layer to do this adjustment because then you can tweak the opacity to get the right amount of blue.

2 Using a *Brush* over the eye, I clicked a few times to desaturate the apparent red-eye. Do this for every eye affected.

3 By adjusting the opacity of this layer, I was able to bring the bright blue eyes to a more natural hue.

Retouching, of course, is where digital really comes into its own. As ever, the huge advantage is that you can keep a copy of the original. With that done, you'll find yourself easily able to fix any niggles in an image.

DENTAL CARE

Cleaning teeth and evening up their colours is easily achieved, and will certainly be appreciated by anyone who forgot to floss.

1 To touch up teeth with a slight stain, I zoom into the area and place a rectangular marquee around the area I want to alter.

2 Using the Cmd (Ctrl)+J key, I create a layer of the area that was inside the rectangular marquee. The beauty of creating a layer is that I can use the opacity settings to emphasize or de-emphasize the effect.

3 Using the *Sponge* tool, a small brush (to stay on the teeth) and a desaturate setting of 20, I go over the teeth. Notice the slight lightening effect compared to the tooth to the right of the brush. Be careful not to go onto the lips or gum area, or they will start to turn grey too.

WHITES OF THE EYES

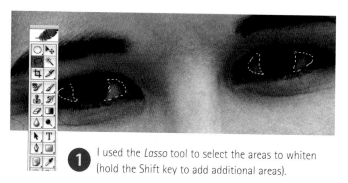

1 I used the *Lasso* tool to select the areas to whiten (hold the Shift key to add additional areas).

2 In *Hue/Saturation* in the *Reds* edit mode, slide the *Saturation* setting to eliminate the slight amount of red in the eye. Click *OK*.

3 In *Hue/Saturation* in *Master* edit mode, adjust the *Lightness* to the right to open up the eyes. Be careful to keep the effect believable.

Retouching like an expert

HEALING BRUSH

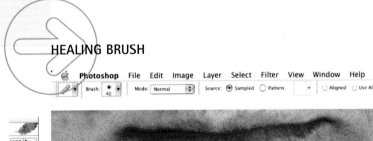

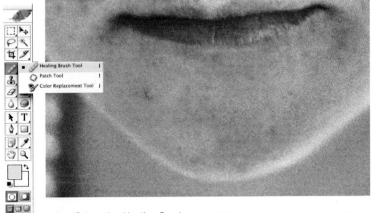

1 Select the *Healing Brush* tool from the Toolbox and work on the duplicate layer (the keyboard shortcut is Cmd(Ctrl)+J). I suppose this isn't quite fair to our bride as she was, after all, having her make-up applied when this photograph was shot. (You'll be glad to know that the make-up was flawless after it was finished and she looked fantastic throughout the day and night.)

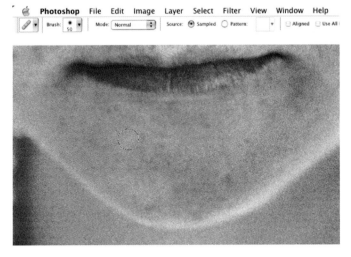

3 Now click on the blemish itself. In virtually one go the slight blemish is covered up with no tell-tale markings.

TIP The *Patch* tool is similar to the *Healing Brush*, but works on selections.

2 Select a brush size in the *Tool Options* bar that is larger than the area you wish to work on. Option/Alt-click on an unblemished area to sample from.

4 Continuing to use the brush (sometimes changing the size though keeping it soft), I was able to conceal some of the other minor blemishes. The *Healing Brush* copies texture but not colour.

DIGITAL DARKROOM TECHNIQUES

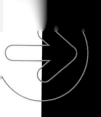

editing software, you'll find that there are usually a variety of ways to do the same thing. The better ways are usually the non-destructive ones, like masks, which don't destroy the original.

TIP When you've finished, check your work at various zooms in case you missed anything.

REMOVING SHINE

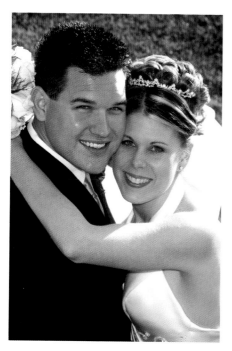

1 A late afternoon session in the hot Arizona sun created some highlights on the brow of the groom. I brought this photograph into Photoshop and tweaked the levels, and did a vignette on the backdrop to get it ready to work on for this section.

2 Working at 100% screen magnification (which most experts suggest for optimum retouching work) I select the *Clone Stamp* and then change the blend mode to *Darken* and reduce the opacity to 50%.

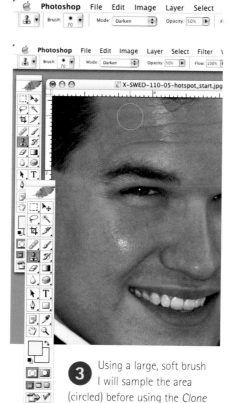

3 Using a large, soft brush I will sample the area (circled) before using the *Clone Stamp* tool to bring down the highlights on the groom's forehead and cheek.

4 The *Clone Stamp* set up in this way did a great job of picking up the highlight area and disguising the groom's slight sweat problem.

GETTING ACCURATE SKIN TONES

Digital cameras are fun and the instant feedback is great, but to save time on all the post-production work, it is important to get as accurate a skin tone and colour temperature as you possibly can at capture.

The most accurate way to do that is to use a Macbeth colour chart (for more info go to: www.gretagmacbeth.com) and then click *Balance* on the chart once it is taken into Photoshop. If the lighting does not change, that same curve can theoretically be applied to similar images in the same lighting.

The camera manufacturers often recommend taking a custom white balance to set the camera to record properly. I have had varying degrees of success, even in controlled situations, though colleagues use it for nearly all their portrait and commercial work.

Since wedding photographers shoot fairly run and gun, the safest way to go is to shoot in the memory-hungry RAW mode and then correct with batch actions in post. If you shoot in JPEG mode, be vigilant of your colour balance settings and watch your exposures closely. JPEGs have very limited room on the top end so being accurate with exposure will give you some leeway in Photoshop later.

Using fill flash (as in the photograph here) can help not only balance the difference between highlight and shadow, but also clean up any colour imbalances in the shadow area. I use a Stofen dome on my flash units, which seems to help the quality of light.

One great thing about weddings is that you almost always have a black value (tux) and white value (shirt or even dress) to sample when taking your curves or levels readings. Sometimes they are not the best sample (unlike from a Macbeth colour chart) but they can do a great job of neutralizing the scene and so helping the flesh tones as a result.

No matter what technique you use, the key is being aware of your colour balance and settings (not to mention exposure) while working – you'll be thankful later.

Black and white

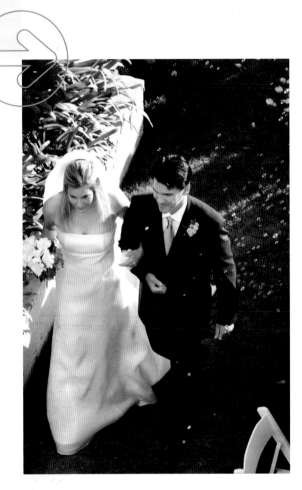

1 Using the *Channel Mixer* in Photoshop is a very flexible way to convert an image to black and white. One can vary the amounts of the Red, Green, and Blue Channels to create a certain look and it can be changed to emphasize certain tones in a photograph. Select the *Channel Mixer* tool using *Image > Adjustments > Channel Mixer.* Alternatively you could use an adjustment layer so your changes are not permanent.

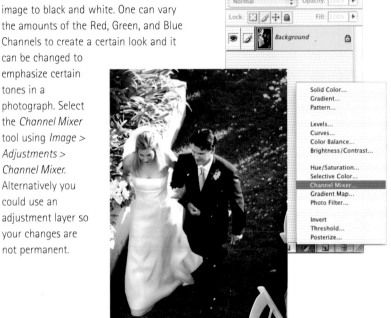

2 Be sure to tick the monochrome box in the lower left corner of the *Channel Mixer* window. An excellent black and white can be created when you have 70 in the Red, 20 in the Green, and 10 in the Blue (as a rule of thumb, the values should add up to 100).

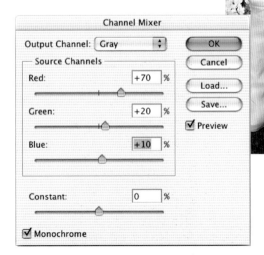

There are many different ways to convert a colour image to black and white. You may capture images in black and white with certain cameras. While this is useful and has some advantages in post-production (you don't have to do conversions), I prefer to capture in colour and then convert to black and white (or sepia) using batch actions in Photoshop. The advantage in capturing in colour and then converting is that you can do virtually anything to the image. In addition, some couples might prefer to have their images in black and white while their parents or friends might prefer those images in colour. Being able to convert the images gives you flexibility.

DIGITAL DARKROOM TECHNIQUES

Black and white conversion on the computer can be a one-click process that a lot of users take for granted. To get really good results, though, it's necessary to spend a little bit of time trying the more advanced options.

TIP Be sure of the end result by testing it on your printer before using your settings on a whole batch.

3 However, there is no need to stick to this combination. You can simply double-click on the adjustment layer to alter the settings again.

Apart from simple black and white, you can also use digital post-production software to create the ever-popular sepia effect. This is easiest to *achieve using the Hue/Saturation dialog or adjustment layer. Simply tick the* Colorize *box and adjust both the* Hue *and* Saturation *sliders to around 35.*

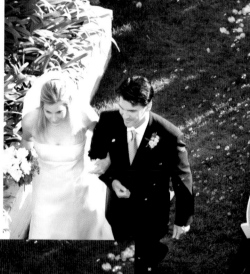

4 My favourite *Channel Mixer* combination is R45 G32 B32. I think it gives a richer and punchier black and white, which harks back to my days in the darkroom. In those days I would try to get the richest blacks out of the photograph without building too much contrast. Feel free to experiment and discover the special mix that you prefer.

FACT FILE

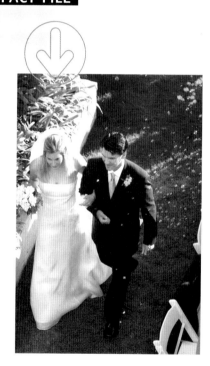

Quickest solution

The quickest way to get a black and white image is to select *Image > Mode > Greyscale*. A box will appear and ask if you want to discard the colour information. Click yes and you have an image with a tonal range like you see above. There is no way to fine-tune the image when converting this way. This default conversion is acceptable but not as powerful as using the *Channel Mixer*.

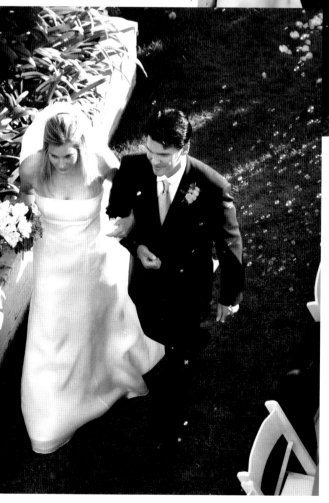

Hand-colouring photos

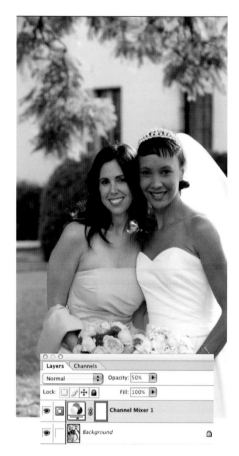

Using Photoshop's layering abilities not only helps you optimize colour and exposure, but also helps you create dramatic images. For example, by being able to convert colour originals to black and white, and then painting back selective areas of colour, it is possible to create looks that appear similar to hand-coloured photographs.

1 Our starting point is this portrait of a bride and her maid of honour. There are a few shots of them already in the album, so this needs to be a bit different. We will use the selective colouring effect to emphasize the flora and fauna, which is not only an interesting effect but a nice way to remind the viewer of the effort that has been put into selecting the venue and the bouquets.

TIP This effect is fairly cool, but may be becoming a bit passé as I write this. Use it judiciously or this effect, like any others, can become overdone.

2 Creating a *Channel Mixer* adjustment layer with these settings, I created a rather muted colour image, reminiscent of a hand-coloured photograph (because the opacity for this layer is set to 50%. If you set it to 100% opacity it will be a totally black and white image). You could stop here, but I'm going to go a bit further.

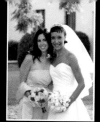

Painting on colours was a trick employed before the days of colour films. In the digital age it is reborn as selective colour, which we can easily employ for artistic effect, just as in the film *Schindler's List*.

TIP Work at a close zoom when creating your masks, or the colour may appear to bleed.

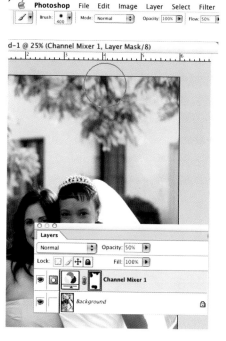

3 Adding a layer mask to the *Channel Mixer* adjustment, I begin to paint back the richer colour in the bouquet and the trees.

4 I created another layer using Cmd (Ctrl)+J and applied a *Gaussian Blur* filter to it.

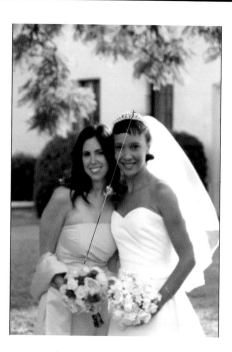

5 I added a mask to the background copy layer and then using the *Gradient* tool I created an area of sharpness.

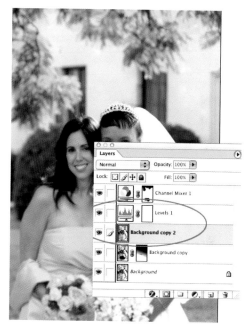

6 While on the background copy, I created a 'stamp down' layer which is done by holding the Option/Alt key as you click on *Layer > Merge Visible*. With this newly created layer, which includes the effects without flattening the image, create a *Levels* adjustment layer and then tweak the highlights and shadows to get an effect you like. The beauty of layers is the ability to go back and tweak your work and adjust amounts to your tastes.

7 After thinking about it, I decided to go into the *Channel Mixer* layer and change the opacity to make that layer more monochromatic. There is just a hint of the pale colour becoming visible in the veil.

Backgrounds and borders

2 Open the *Drop Shadow* layer style from the drop-down menu on the *Layers* palette (accessed from the leftmost button at the bottom of the window).

TIP If you copy your images by dragging from a *Layers* palette, hold Shift to centre.

Creating borders, key lines, and drop shadows is easy to do, and creates emphasis. The two ideas here are really just a start.

1 After the original photograph is toned and ready to go, create a new document (here 12 x 12 inches at 300 ppi). Copy and paste the original into the new document. Make sure both documents have the same colour space (which is important for output).

3 Adjust the distance, spread, and size to create the type of shadow that you want.

4 After the drop shadow is placed, you can add an outer glow which, I think, gives the photograph an even more three-dimensional quality. The default is to a pale yellow colour and I usually change that to a light grey or white line.

DIGITAL DARKROOM TECHNIQUES

A STRONG BORDER

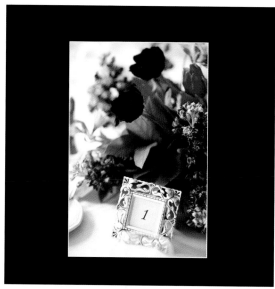

2 Now going to the *Edit* menu, drop down to the *Fill* command.

The black background makes quite a difference in the entire look of the image, and a simple white border makes it even more effective.

1 Place the image over a new background as in step one on the left-hand page, or remove the layer styles you've applied to it. Select the background layer in the *Layers* palette. (If you want a coloured background, you should select the colour as a foreground colour at this point.)

3 Indicate in the *Use* pull-down that the colour to use is black (though it could be 50% grey, or any colour sampled in Photoshop). Click *OK* to fill the background with black.

4 We need to offset the image from the black so go to the effects button in the layer window (after highlighting the layer with the photograph) and create a stroke.

5 Since the default colour that appears with a stroke is red, click on the colour to get the *Color Picker*, then select white. Click *OK*.

6 Finally, adjust the size of the stroke to 10 pixels and position it on the inside to create the final image.

Removing backgrounds

While it is possible to do virtually anything with Photoshop, I try to keep it pretty simple. One of the techniques that I use sparingly, if at all, is removing someone from the scene and placing him or her in a different background (or in this case, against a totally white background). I'm probably old-fashioned, but my goal is to get it in one image, whether it is on one piece of film or with one click of the shutter on a digital camera. Still, there are times when I have a photograph that might be nice against a clean white background when used in my website, or in the layout and design of an album. Here's an example of how to make an extraction of a subject for doing something like that.

TIP If your aim is to place your subject elsewhere, be mindful of the lighting.

1 This is the photograph that I want to work on to extract the part of the father dancing with his daughter to be used as a splash screen on a website home page.

2 Select *Filter > Extract*.

3 I begin to outline the area to extract with the marker and draw around the subjects. These types of retouching work are trickier to do with a mouse or trackball and easier to do with an electronic drawing tablet and pen.

The *Extract* filter is a handy shortcut for removing backgrounds, and the extracted image can be placed into another background too. An alternative, more laborious, method is to mask out the areas around your subject.

8 In the newly created layer, fill it (in this case) with white. You can add any colour that you want, but I wanted a clean white background.

4 Once the subjects are outlined go to the *Paint Bucket* icon (upper left), and then click inside the outlines to fill the area. Once this area is filled, click on the *Preview* button at upper right so you can see at what the extraction will look like once done.

6 Copy the layer using *Layer > New > Layer via Copy.*

9 Click on the fill layer (Layer 1 in the *Layers* palette) and drag it underneath the image of the subjects.

5 Select the *Cleanup* tool and work around the edge of the extraction. You may see some gaps caused by the original extraction so paint over them with your brush. Hold the Option/Alt key down to paint back anything missing. This is a bit tedious but doing a good job here is important. Once done, use the *Edge* tool to define the edge around the subjects and finally click *OK*.

7 Create a new layer. This layer will be turned into the background.

10 Go to *Layer > Flatten Image*. If there are any areas to clean up, use the *Clone Stamp* tool to cover them.

11 I opened another file for the logo, which I wanted to place in the upper right part of the image. Copy Cmd (Ctrl)+C and paste Cmd (Ctrl)+V the logo onto the main image.

Removing unwanted picture elements

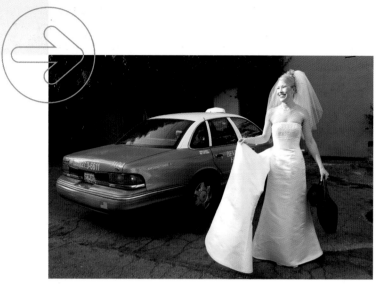

You can view Photoshop as little more than a glorified enlarger, free of caustic chemicals, but doing the same job in the workflow. That's a bit of a waste though; photojournalistic ethics aside, Photoshop is capable of a lot more than dodging and burning. Image elements such as light switches and exit signs can be eliminated with ease. Even, if necessary, a great-aunt who said something she shouldn't have done. It's almost too easy, really.

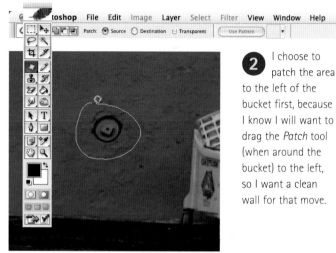

2 I choose to patch the area to the left of the bucket first, because I know I will want to drag the *Patch* tool (when around the bucket) to the left, so I want a clean wall for that move.

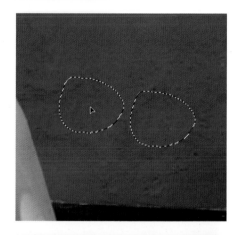

3 Click and drag to the clean wall to the left, release the mouse and the wall is remarkably clean. I needed to do no additional touch-up after the patch here.

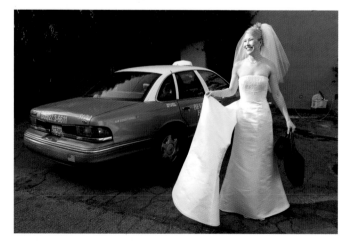

1 Since the ceremony and reception were held at a restaurant, it's no surprise that a bucket was close to the building and right in the background of this image (taken with a 16–35mm zoom lens). The *Clone Stamp* or *Patch* tools are our allies here.

4 While using the *Patch* tool, I click and drag and draw around the bucket, trying to stay close to the wheels and the wall on top of the item, though a distance of a few pixels is advisable.

While some of the other things we've seen before are simply easier methods of achieving darkroom arts, removing objects altogether is essentially a digital art. Let your instinct for the image, rather than concern for reality, win.

5 As you click and drag, the patch target updates to reflect the new source, so you can line up that edge with ease.

6 Once happy with the bucket's elimination, release the mouse and it is removed. Be sure and keep things as straight as possible where there is a line to follow, like that between the wall and ground here.

7 Again, because of the line, you will find the *Clone Stamp* tool more useful than the *Healing Brush* while tidying up.

RECAP

A Select
Select the *Patch* tool from the Toolbox and use it to draw an outline around any object you need to remove.

B Drag
Click and hold the selection and drag the 'patch' to your source area – the target area will update from it.

C Touch up
When you've finished, you may need to use an accurate tool, like the *Clone Stamp*, to tidy up the results.

TIP Don't neglect cropping as a way to remove objects from an image.

Montages

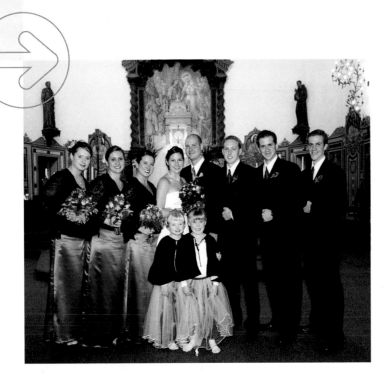

When shooting group portraits – especially with little ones in the bridal party – it is often tricky to get a good smile out of everyone in the same frame. For larger groups, try to shoot at least five images of the entire group. With that many you should get a pleasing reaction from everyone on at least one frame, even the rather blasé bridesmaid here!

1 Neither of the little girls is smiling, so we will take a photograph of them smiling from one of the other group photos, and place it in this frame.

TIP You can also take subjects from other images with the *Extract* filter.

2 Both girls have much better expressions in this image (immediately after the first frame) so we will take them and place them into the other frame. Using the *Rectangular Marquee* tool (upper left corner) I highlight and select an area around the two girls.

3 Go to *Edit > Copy* to place a copy of the area selected into the clipboard.

4 Now switch to the target image and click *Edit > Paste* and the image of the smiling girls will appear on a new layer in the new image.

Placing people onto different photographs isn't a new idea – ask Stalin – but with the ease of working in digital it's easy and quick enough to be a practical solution to the problems of working with children and animals.

5 The new image will not appear in exactly the right spot. Select the *Move* tool from the Toolbox and position the image as best as possible. It might help to temporarily turn the layer's opacity down to 50% so you can line things up.

6 While the copy is almost a perfect match, there are a few gaps, which could have been caused by slight movement or even a slight change of camera position. Still working at 50% opacity, the girls needed to be scaled slightly using the *Edit > Free Transform* tool Cmd (Ctrl)+T. Holding the Shift key to maintain proportions, move the upper left or lower right corner points to get the scale as close as you can.

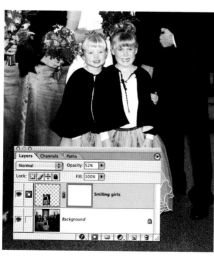

8 Begin to paint and you will notice that some of the seams between layers will disappear but some (as on the area at right between the best man's legs as well as the front of the carpet), will need more extensive work. If you want to see where you have painted, remember to hit the backslash (\) key, and you will see the area painted.

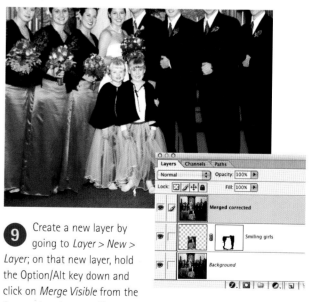

7 Make any final position changes by dragging inside the *Free Transform* tool's boundaries, then accept your changes and restore the layer opacity to 100%. Now create a layer mask. On this mask we can use black to paint back the mask and reveal the background layer. If your originals are lined up nicely already, you may not need to create the layer mask, but since you aren't destroying any information, masking is very useful in this context.

9 Create a new layer by going to *Layer > New > Layer*; on that new layer, hold the Option/Alt key down and click on *Merge Visible* from the *Layer* palette's menu. The new layer now incorporates the previous two layers, so you can now begin to clone or patch the areas that don't quite match. Using a variety of tools to keep the area looking natural, you can tidy up areas like that beneath the best man.

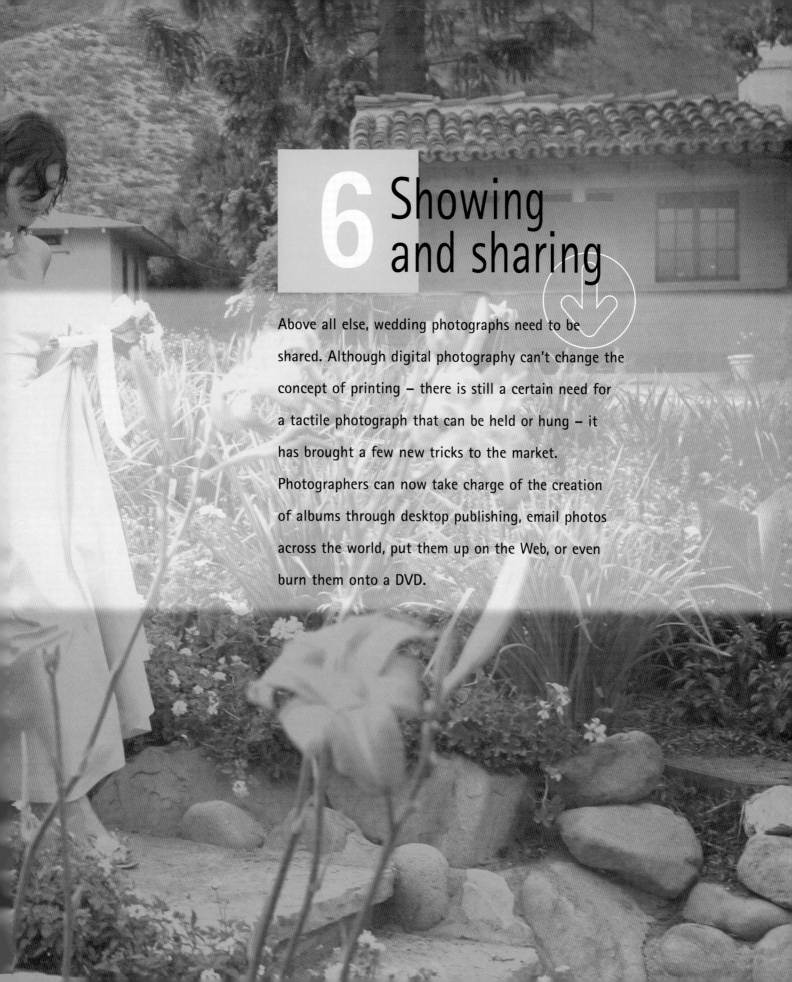

6 Showing and sharing

Above all else, wedding photographs need to be shared. Although digital photography can't change the concept of printing – there is still a certain need for a tactile photograph that can be held or hung – it has brought a few new tricks to the market. Photographers can now take charge of the creation of albums through desktop publishing, email photos across the world, put them up on the Web, or even burn them onto a DVD.

How to get perfect prints

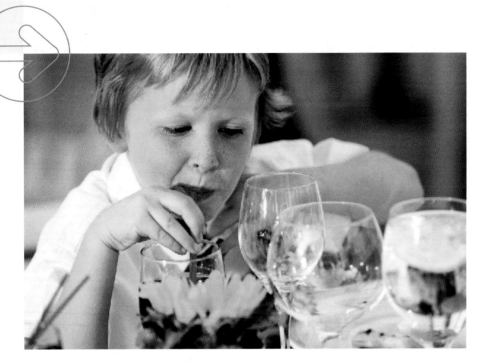

High-quality printing is now available on your desktop, thanks to the engineering skills of the people at Epson, Canon, and the others. Inkjet printing has revolutionized photographic output nearly as much as digital has revolutionized capture. Manufacturers continue to improve the printers with ever-finer ink droplets and longer archival ratings.

The DIY printer revolution is in full force, and with even a reasonably standard home inkjet printer you can produce excellent quality prints. This is all the easier if you calibrate your system using modern colour profiles.

Ideally, use a professional, high-quality monitor for doing colour-critical work. The truth is that old-fashioned CRT (Cathode Ray Tube) monitors give the best overall, and most accurate, colour. Many studios use bulky CRT monitors for their critical colour work and stylish flat panel monitors to show the client. A monitor should be calibrated monthly to maintain accuracy, ideally using a specialized device or, failing that, by eye (see Fact File).

To get truly accurate print output, it is ideal to have a printer profile made for your specific output device. If you print with a lab, they will probably have a profile of their printer which they'll make available to you, together with instructions for installing it onto your system.

In Mac OS, profiles are kept in the *Users > Library > ColorSynch > Profiles* folder. In Windows, you can associate a profile to a printer in the *Printers* section of the *Control Panel* and following the instructions under the *Color Management* tab. With that in place, colour management is simply a matter of ensuring that you select the correct profile in the *Print* dialog.

Finally, there are a few more things worth considering before you click on that *File > Print* button. The one that causes most confusion is usually the resolution. Modern printers have huge-sounding resolutions in the 1,440 and even 2,880dpi (dots per inch) territories. It might seem logical, then, to set your image resolution to the same amount. Your image, however, is measured in pixels per inch, and the difference is important.

A pixel on the screen can be any one of many millions of colours, whereas your printer's 'dots' are either on or off – there is, or is not, a droplet of ink there, from any or all of the four (or six) colours of ink inside. These dots are arranged in a pattern (a halftone) so that they blend to create the many shades. Owing to paper grain, the limits of technology and the limits of the human eye, there is rarely anything to gain by printing above 300ppi.

1 To tweak your work ready for output, first click *Image > Size > Resize* to set the dimensions and resolution (this is also the time to apply any *Unsharp Mask*).

```
Image Size
Pixel Dimensions: 14.0M (was 6.40M)
    Width:  2700    pixels          OK
    Height: 1815    pixels          Cancel
                                    Auto...
Document Size:
    Width:  9        inches
    Height: 6.049    inches
    Resolution: 300  pixels/inch
☑ Scale Styles
☑ Constrain Proportions
☑ Resample Image: Bicubic
```

2 Go to *File > Page Setup* and ensure that you have the correct printer, page size, and page orientation selected. The appearance of the dialog may vary under Windows.

```
Page Setup
Settings:    Page Attributes
Format for:  Stylus Photo 2200
             EPSON Stylus Photo 2200...
Paper Size:  US Letter
             8.50 in x 11.00 in
Orientation: 
Scale: 100  %
                        Cancel    OK
```

It is easy to overlook printing when you immerse yourself in the digital world, but in fact this is an area where you suddenly have a great deal more responsibility. No longer can you depend on the chemist for colour accuracy.

3 Go to *File > Print* and then scroll down to the *Printer Features* Menu. Select the appropriate quality and media settings for your printer for best results (again, the exact appearance of these dialogs varies from printer to printer). Click *Print*.

Alternatively, for a few more options, you can print via the *File > Print with Preview* dialog. Here you have simple visual feedback on the final appearance of the page (including centring). Under the *Color Management* options, I have selected a profile for the type of paper being used. This is critical to getting good prints.

Colour calibration

A You can calibrate your monitor without a dedicated colourometer from Mac or PC. On the Mac, open the *Displays* window in *System Preferences* and click the *Color* tab. (In Windows you will find *Adobe Gamma* in the *Control Panel* if you have any Adobe software).

B You can then follow on-screen steps. First you will be shown how to adjust your monitor.

C Then you can make certain adjustments based on your working environment. The process is explained onscreen.

D Finally, give your profile a sensible name (include the monitor brand). It will be added to the list available on your computer.

Digital photo albums

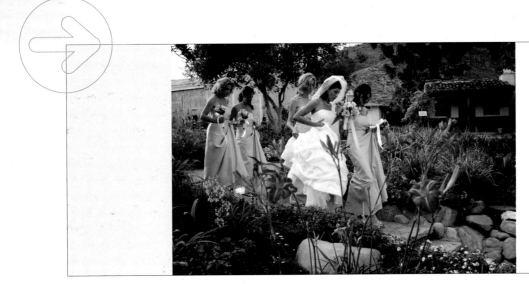

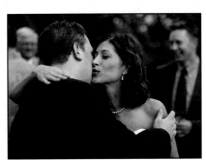

I love making albums for couples because it gives me a chance to showcase my editing and design skills. As a former journalist whose work was often edited by others, it is nice to regain control in terms of the layout and editing choices (that said, I always defer to the wishes of the client, of course).

1 After the photo is ready to add to the album layout, I create a new document that is equal to the size of the double page spread (depends on the album size – this album will be 8 x 12 inches, so the spread is 8 x 24 inches at 300 pixels per inch). Be sure your colour profile is accurate for your printer. Adobe RGB is for Durst Lambda printers or for press, but sRGB is commonly used for photographic or even inkjet printers.

2 Once the new file pops up, I create guides at the halfway points that aid in layout. To do that, mouse into the ruler, click and hold, and the light blue guide will appear. Do this for both midpoints. Having the centre guide is critical to know where the gutter or margin of the book will affect the photograph. I copy and paste the original file into the new spread, and the photograph appears exactly centred within the spread.

TIP Make totally sure that your page dimensions are correct before you begin.

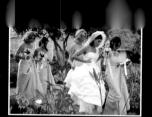
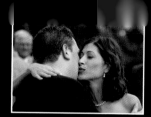

Creating photo albums digitally borders onto a whole new art: desktop publishing. You might find it's asking a lot of you, taking on so many varied skills, but it's worth persevering. Many photographers get a lot out of it.

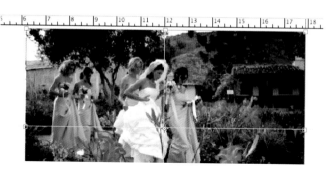

3 With the newly pasted photo layer activated, use the *Free Transform* tool to expand or contract the size of the image. The key to using the *Free Transform* tool is this: hold the Shift key down as you drag the image from the corners and the image will stay proportional. Without Shift, it'll stretch oddly.

4 To add a dash of colour for this illustration I sampled some colour from the bride's dress using the *Eyedropper* tool and then used the *Gradient* tool to place a gradient of this colour in the background of the page.

5 To give texture to the background add some noise using *Filter > Noise > Add Noise*. Here, I set the noise to 18, though you can adjust it to taste.

6 I copied and pasted the second photo onto the larger spread above, and the photograph defaults to the centre of the document. Using the *Free Transform* tool as before, I resized this second photograph and placed it in its final position on the page, using the guides. (If necessary, you can crop at this stage by selecting the area to keep, choosing *Select > Inverse* and deleting the area you don't want.)

7 Save your documents as layered Photoshop files. This uses a lot of space, but you can save some of this by turning off the *Maximize compatibility* option.

8 Finally you need to print your work. This clearly depends on your choice of device, but it's possible you'll need to crop your spread into two individual pages. If so, use the *Image > Canvas Size* dialog and type in the new, smaller dimensions. Click on the *Anchor* in either the left or right square (depending on which page you are saving) then, after clicking *OK*, immediately click *File > Save As*. under a new name.

Digital photo essays

Digitally created 'essays' need not lose the style of a traditional album. In fact this is your opportunity to be all the more creative.

My albums typically have 70 or more images and currently I ask the couple to select their favourite images. I edit my favourites and let the couple see them, and so the process of telling the story with the album begins.

I use iView Media Pro cataloguing software to organize the photographs for the album, whether they were shot digitally or from scanned film images. Either way, I utilize this digital workflow to create a custom product for the couple.

A s a former newspaper photojournalist, I spent a career telling stories with pictures. Now, as I pursue documentary wedding photography, I still tell stories. That is one of the things that got me into wedding photography: my documentary roots.

Using iView Media Pro I am able to see the relationship between each two-page spread, but I can also see how the essay flows from spread to spread. I find this invaluable when telling the story of the wedding day (and creating an album).

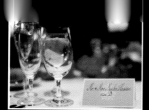
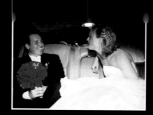

An album is a great way to present your photographs, but it's certainly not the only way. Many specialist printshops, as well as websites like cafepress.com, can help you create mugs, plates, calendars or even underwear from your images.

TIP Using proper cataloguing software will also make it easier to back up your work.

Here is a two-page spread originally created in Photoshop and saved in .psd format and then imported into iView. By creating the two-page spreads, I am able to keep relationships between photographs intact and look at the entire album flow.

What pictures to include? Of course, the typical photographs of the ring exchange – in fact most of the categories we covered in the early part of the book – and then I look for detail photographs, photos with great emotion or expression. I look for photographs that make me stop and want to look at them.

The approach that I take to the wedding is to try to capture the elements of the day that are unique. Even though there are obvious recurring themes in every wedding, the things that make each unique need to be shown.

Those characteristics can take the form of weather, details, location, and the like. I think the thing that moves me most, though, is people expressing emotion.

When it comes to the edit, I like to start the album with my favourite of the couple together, whether it is a portrait, the two of them at the altar, the kiss at the altar, or of them walking down the aisle.

In this case, I selected a photograph of the couple coming down the aisle, and then turned it into a sepia-toned photograph.

I sized the thumbnails to allow the entire album to be seen in this window. I can easily take one spread and rearrange it if I choose. From this software, I also create the Web galleries (see pages 136–137).

Slideshows on CD-ROM

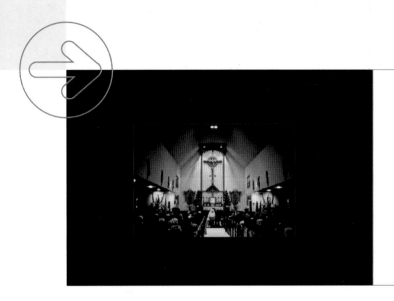
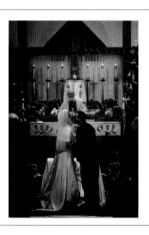

Photoshop CS has a neat new feature in it that gives you a powerful presentation option that is secure. Photoshop now allows you to create an Adobe Acrobat file that is also a slideshow. You can also disable any printing of the file so it prevents copying of your images. One of the best things about Acrobat files is that they are cross-platform, so users of Windows and Macintosh computers both have the ability to read these files.

1 Go to *File > Automate > PDF Presentations* to begin.

2 You need to tell Photoshop the source images you plan to use, so click on the *Browse* button to get to the folder. You will have to highlight each individual image in the folder before being able to launch them. If you are going to use any of the glitter transitions, allow more than five seconds as they are very slow. It will look choppy if there is not enough time. Also, it's very important to have the most current version of Acrobat Reader to see the effects in the slideshow. While the show is viewable in versions earlier than 6, you will not see the fancy transitions.

3 Give the file a name and tell the computer where to save it.

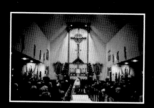
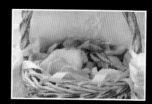

Both Acrobat readers and QuickTime players are available for both Mac and PC, old and new, and can be downloaded for free, though people normally have them already. You could even include the reader software on the CD.

QUICKTIME

Another cross-platform presentation is to make a QuickTime film, to which you can even add background music.

4 In this window you tell Photoshop what level of JPEG to save, as well as other options such as *PDF Security*. Tick the box and then click on the *Security Settings* button that reveals this window.

5 By clicking on *Password Required to Change Permission and Passwords*, you make this a secure document. By clicking the boxes in the middle you can prevent recipients from altering or even printing the document.

2 This box dictates the look of the actual slideshow. Click on *Full Screen Mode* and when the film launches it will be centred on a black screen.

1 Under the *Make > Slide Show Options*, I tell iView the duration the slide is on the screen as well as the type of transition I want. Once you've got it the way you like, click *OK*. Once the parameters are set for the slideshow, go to *Make > Save Slide Show as Movie*.

TIP Double-check to make sure all your images are properly orientated before starting.

Multimedia DVDs

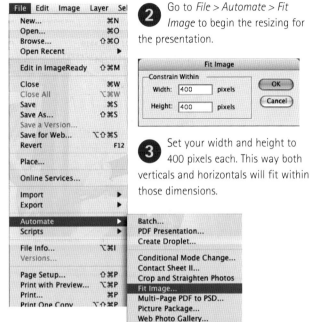

Go to *File > Automate > Fit Image* to begin the resizing for the presentation.

Set your width and height to 400 pixels each. This way both verticals and horizontals will fit within those dimensions.

Creating a professional-looking DVD is no longer the domain of Hollywood studios. Now, using inexpensive software, you're able to create a DVD slideshow that will play on most home players as well as computers. Using Apple's iDVD in conjunction with iPhoto (both included with all Apple computers) you can create a DVD that will allow your couples to relive their wedding day from the comfort of their living room.

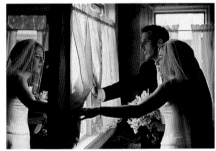

Take a small, low-resolution file into Photoshop. Sharpen it and do any conversions to black and white at this stage. Don't use your full-size digital files or large scans, as they are simply too big for the software to run effectively.

Set the dimensions of your canvas to 640 x 480 and make sure that the canvas extension colour is set for black. These are the basic proportions of traditional television monitors. If you make them any larger, you run the risk of having the images bleed off the television screen. If you size them the way I recommend, you will have your images centred on your television monitor.

Using the same dimensions as the images for the DVD show you can create title slides in Photoshop, which improve the presentation's overall impact.

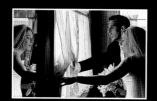
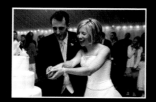

Unlike image-editing, where Photoshop rules the roost, this is a more dynamic area of software. iDVD on the Mac is a good example, but users could also consider Pinnacle's Instant PhotoAlbum or Adobe Photoshop Album.

TIP You can create an action in Photoshop that will do all this tedious work to your folder of images.

8 Once the photos have been transferred, select the amount of time each photo will be seen, and the type of transition involved. If you place music as a soundtrack to the show, you can edit the show to fit the time constraints of the music. Depending on the software you use, you will also be able to add visual effects, text, and other effects. Be careful not to detract from the images, however, since they are the object of the exercise.

6 After your title slides are made, launch iPhoto and drag the folder of prepared images into the program. You can make changes to the order here.

7 At this level you highlight the photos (at left) and then click and drag them into the field at upper right. From this level you can also shuffle the order if you prefer.

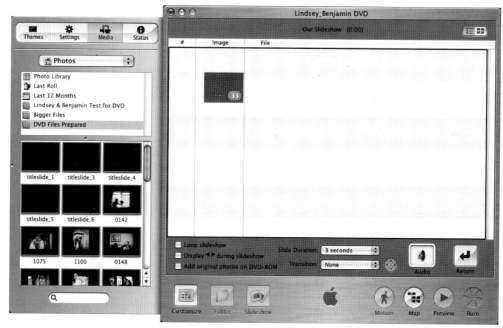

Putting pictures on the Web

1 Using Photoshop, go to the *File > Automate > Web Photo Gallery* to start the process.

Adobe Photoshop has allowed photographers to create Web galleries from their images, which can be uploaded to the Web. Now Photoshop and other third-party software solutions handle the tedious resizing of photographs, and the generation of Web code to post the galleries.

2 When the *Web Photo Gallery* window opens you have to designate the source folder as well as the destination folder (bottom). This destination folder is the folder that will be uploaded to the Web; the name of the folder will become part of the URL (in this case it would be http://www. paulfgero.com/webgallery for_webgallerychapter/).

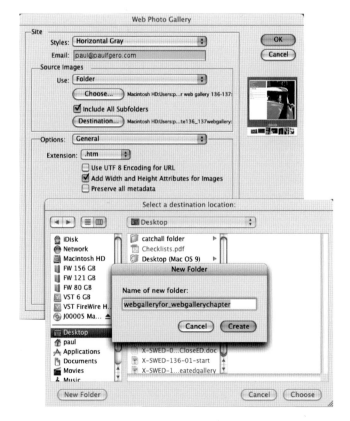

TIP Don't post high-resolution files on the Internet – you're risking your own copyright.

Web galleries are just one function of dedicated image databases like iView Media Pro (available for both Mac and Windows). You can also sort your images into catalogues, make them searchable by keywords, and print pages.

3 Once Photoshop finishes the action, it launches your Web browser to give you an idea how the Web gallery will look once online.

4 Once the Web gallery is created and placed in the folder it needs to be placed on your website. Use an FTP (File Transfer Protocol) utility like Transmit by Panic Software (http://www. panic.com) to upload the files. There are equivalents in Windows or you can use Explorer.

ALTERNATIVE SOFTWARE

1 An alternative, again for Mac or PC, is to use iView Media Pro to create web galleries. Media Pro is an image-cataloguing program, so it can include a range of extra data.

2 In iView, click *Make > HTML Gallery* to begin the automated process.

3 Give your site a title and select a theme (Mac users will like Aqua). You can also choose the size of the thumbnails and the full size files in iView.

Glossary

aliasing The jagged appearance of diagonal lines in an image, caused by the square shape of pixels.

alpha channel A greyscale version of an image that can be used in conjunction with the other three colour channels for storing a mask or selection.

anti-aliasing The smoothing of jagged edges on diagonal lines created in an imaging program, by giving intermediate values to pixels between the steps.

aperture The opening behind the camera lens through which light passes on its way to the CCD.

application Software designed to make the computer perform a specific task. An image-editing program is an application, as is a word processor.

artifact A flaw in a digital image.

ASA American standard for film speed, roughly equivalent to the ISO rating.

aspect ratio The ratio of the height to the width of an image, screen, or page.

autofocus A system used in most traditional and digital cameras to ensure that the subject of a photo will be in focus at the moment the exposure is taken.

backup A copy of a file kept for safety reasons, in case the original becomes damaged or lost. Make backups on a regular basis.

bit (binary digit) The smallest data unit of binary computing, being a single 1 or 0. Eight bits make up one byte. See also Byte.

bit depth The number of bits of colour data for each pixel in a digital image. A photographic-quality image needs eight bits for each of the red, green, and blue colour channels, making for a bit-depth of 24.

bitmap An image composed of a grid of pixels, each with their own colour and brightness values. When viewed at actual pixel size or less, the image resembles a continuous tone shot, like a photograph.

blend mode A setting in the Photoshop/Photoshop Elements layers palette, which controls how the pixels in one layer affect those in the layers below.

brightness The level of light intensity. One of the three dimensions of colour. See also Hue and Saturation.

byte Eight bits – the basic data unit of desktop computing. See also Bit.

calibration The process of adjusting a device, such as a monitor, so that it works consistently with others, such as scanners and printers.

CCD (Charge-Coupled Device) A tiny photocell, made more sensitive by carrying an electrical charge before it is exposed, and used to turn light into an electronic signal. Used in densely packed arrays, CCDs are the recording medium in some scanners and most digital cameras.

CD (Compact Disc) Optical storage medium. As well as the read-only CD-ROM format, used by most computers to install applications, there are two recordable CD formats. On a CD-R (Compact Disc-Recordable), each area of the disc can only be written to once, although it's possible to keep adding data in different 'sessions'. On a CD-RW (Compact Disc-Rewritable) the data can be overwritten many times.

channel Part of an image as stored in the computer; similar to a layer. Commonly, a colour image will have a channel allocated to each primary colour (e.g. RGB) and sometimes one or more for a mask or other effects. See Alpha channel.

cloning In an image-editing program, the process of duplicating pixels from one part of an image to another.

CMOS (Complementary Metal-Oxide Semiconductor) An alternative sensor technology to the CCD, CMOS chips are used in ultra high-resolution cameras from Canon and Kodak.

CMS (Colour Management System) Software (and sometimes hardware) that ensures colour consistency between different devices, so that at all stages of image-editing, from input to output, the colour balance stays the same.

CMYK (Cyan, Magenta, Yellow, Key) The four process colours used for printing, including black (key).

compression Technique for reducing the amount of space that a file occupies, by removing redundant data.

continuous-tone image An image, such as a photograph, in which there is a smooth progression of tones between black and white.

contrast The range of tones across an image, from bright highlights to dark shadows.

cropping The process of removing unwanted areas of an image, leaving behind the most significant elements.

default The standard setting or action used by an application, unless deliberately changed by the user.

depth of field The distance in front of and behind the point of focus in a photograph in which the scene remains at an acceptable level of sharp focus.

dialog An on-screen window in an application that is used to enter or adjust settings to complete a procedure.

diffusion The scattering of light by a material, resulting in a softening of the light and of any shadows cast. Diffusion occurs in nature through mist and cloud cover, and can also be simulated in professional lighting setups using diffusion sheets and soft-boxes.

digital A way of representing any form of information in numerical form as a number of distinct units. A digital image needs a very large number of units so that it appears as a continuous-tone image to the eye; when it is displayed, these are in the form of pixels.

dithering A technique used to create an illusion of true colour and continuous tone in situations where only a few colours are actually used. By arranging tiny dots of four or more colours into complex patterns, the printer or display produces an appearance of there being more than 16 million visible colours.

dMax (Maximum Density) The maximum density – that is, the darkest tone – that can be recorded by a device.

dMin (Minimum Density) The minimum density – that is, the brightest tone – that can be recorded by a device.

download Sending a data file from the computer to another device, such as a printer. This has come to mean taking a file from the Internet or a remote server and copying it to a desktop computer.

dpi (dots-per-inch) A measure of resolution in halftone printing. See also ppi.

drag To move an icon or a selected image across the screen, normally by moving the mouse while keeping its button pressed.

dynamic range The range of tones that an imaging device can distinguish, measured as the difference between its dMin and dMax. The dynamic range is affected by the sensitivity of the hardware and by the bit depth.

feathering The fading of the edge of a digital image or selection.

file format The method of writing and storing information (such as an image) in digital form.

fill-in flash A technique that uses the on-camera flash or an external flash in combination with natural or ambient light to reveal detail in the scene and reduce shadows.

filter (1) A thin sheet of transparent material placed over a camera lens to modify the quality of colour or light that reaches the film or sensor.

filter (2) A feature in an image-editing application that alters or transforms selected pixels for some kind of visual effect.

focal length The distance between the optical centre of a lens and its point of focus when the lens is focused on infinity.

focal range The range over which a camera or lens is able to focus on a subject (for example, 0.5m to infinity).

focus The optical state where the light rays converge on the film or CCD to produce the sharpest possible image.

fringe A usually unwanted border effect to a selection, where the pixels combine some of the colours inside the selection and some from the background.

f-stop The calibration of the aperture size of a photographic lens.

GB (gigabyte) Approximately one thousand megabytes or one billion bytes (actually 1,073,741,824).

gradation The smooth blending of one tone or colour into another, or from transparent to coloured in a tint. A graduated lens filter, for instance, might be dark on one side, fading to clear on the other.

graphics tablet A flat, rectangular board with electronic circuitry that is sensitive to the pressure of a

stylus. Connected to a computer, it can be configured to represent the screen area and then be used for drawing.

greyscale An image made up of a sequential series of 256 grey tones, covering the entire gamut between black and white.

GUI (Graphic User Interface) Screen display that uses icons and other graphic means to simplify using a computer.

handle Icon used in an imaging application to manipulate a picture element. They usually appear on-screen as small black squares.

histogram A map of the distribution of tones in an image, arranged as a graph. The horizontal axis goes from the darkest tones to the lightest, while the vertical axis shows the number of pixels in that range.

hot-shoe An accessory fitting found on most digital and film SLR cameras and some high-end compact models, normally used to control an external flash unit.

HSB (Hue, Saturation, Brightness) The standard colour model used to adjust colour in many image-editing applications.

hue The pure colour defined by position on the colour spectrum; what is generally meant by 'colour' in lay terms. See also Brightness and Saturation.

Glossary

image-editing program Software that makes it possible to enhance and alter a digital image.

interpolation A procedure used when resizing a bitmap image to maintain resolution. When the number of pixels is increased beyond the number of pixels existing in the image, interpolation creates new pixels to fill in the gaps by comparing the values of adjacent pixels.

ISO An international standard rating for film speed, with the film getting faster as the rating increases. ISO 400 film is twice as fast as ISO 200, and will produce a correct exposure with less light and/or a shorter exposure. However, higher-speed film tends to produce more grain in the exposure, too.

JPEG (Joint Photographic Experts Group) Pronounced 'jay-peg', a system for compressing images, developed as an industry standard by the International Standards Organization. Compression ratios are typically between 10:1 and 20:1, but data is lost permanently in the process. Higher levels of JPEG compression mean more loss, therefore a lower-quality image.

KB (kilobyte) Approximately one thousand bytes (actually 1,024).

lasso A selection tool used to draw an outline around an area of an image for the purposes of selection.

layer One level of an image file, to which elements of an image can be moved or copied, allowing them to be manipulated or edited separately.

luminosity The brightness of a colour, independent of its hue or saturation.

macro A mode offered by some lenses and cameras that enables the lens or camera to focus on objects in extreme close-up.

mask A greyscale template that hides part of an image. One of the most important tools in editing an image, it is used to limit changes to a particular area or to protect part of an image from alteration.

MB (megabyte) Approximately one thousand kilobytes or one million bytes (actually 1,048,576).

megapixel A rating of resolution for a digital camera, directly related to the number of pixels forming or output by the CMOS or CCD sensor. The higher the megapixel rating, the higher the resolution of images created by the camera.

memory card The storage format used by most digital cameras, where images are saved to solid-state memory embedded in some form of small plastic housing. Common types include Compact Flash, SmartMedia, SD Memory Card, and XD Memory Card.

menu In an application, an on-screen list of choices and commands used to access features or change settings.

microdrive Miniature hard disk designed to fit in the memory-card slot of a digital camera and so increase the storage capacity.

midtone The parts of an image that are approximately average in tone, falling midway between the highlights and shadows.

mode One of a number of alternative operating conditions for a program. For instance, in an image-editing program, colour and greyscale are two possible modes.

noise Random pattern of small spots on a digital image. Generally unwanted and caused by non-image-forming electrical signals.

paste To place a copied image or digital element into an open file. In image-editing programs, this normally takes place in a new layer.

peripheral An additional hardware device connected to and operated by the computer, such as a drive or printer.

pixel (PICture ELement) The smallest unit of a digitized image – the square screen dots that make up a bitmapped picture. Each pixel carries a specific tone and colour.

plug-in Software produced by a third party and intended to supplement a program's performance.

ppi (pixels per inch) A measure of resolution for a bitmapped image.

RAM (Random Access Memory) The working memory of a computer, to which the central processing unit (CPU) has direct, immediate access.

RAW A file format created by some high-end digital cameras, containing all the pixel information with no compression. Usually requires proprietary software supplied with the camera to view, adjust, and convert the files.

resampling Changing the resolution of an image either by removing pixels (lowering resolution) or adding them by interpolation (increasing resolution).

resolution The level of detail in an image, measured in pixels (e.g. 1,024 by 768 pixels), lines per inch (on a monitor), or dots per inch (in a halftone image, e.g. 1,200 dpi).

RGB (Red, Green, Blue) The primary colours of the additive model, used in monitors and image-editing programs.

saturation The purity of a colour, going from the lightest tint to the deepest, most saturated tone.

scanner Device that digitizes an image or real object into a bitmapped image. Flatbed scanners accept flat artwork as originals; slide scanners accept 35mm transparencies and negatives.

selection A part of the on-screen image that is chosen and defined by a border, in preparation for manipulation or movement.

shutter The mechanical device inside a conventional camera that controls the length of time during which the film is exposed to light. Many digital cameras don't have a shutter as such, but the term is still used as shorthand to describe the electronic mechanism that controls the length of exposure for the CCD.

shutter lag The time delay between pressing the shutter release on a digital camera and the exposure being made. The length of this delay was a problem with early digital cameras.

shutter speed The time the shutter (or electronic switch) leaves the CCD or film open to light during an exposure.

SLR (Single Lens Reflex) A camera that transmits the same image via a mirror to the film and viewfinder, ensuring that you get exactly what you see in terms of focus and composition.

spot meter A specialized light meter, or function of the camera light meter, that takes an exposure reading for a precise area of a scene. This is particularly useful for ensuring that vital parts of the scene are correctly exposed.

SuperCCD A CCD in which the pixels are oriented as diamonds. Processing the readout of each line of pixels requires some degree of interpolation, but gives a resolution higher than the pixel count.

telephoto A photographic lens with a long focal length that enables distant objects to be enlarged. The drawbacks include a limited depth of field and angle of view.

thumbnail Miniature on-screen representation of an image file.

TIFF (Tagged Image File Format) A file format for bitmapped images, which can use lossless LZW compression (no data is discarded). The most widely used standard for high-resolution digital photographic images once they have been downloaded from the digital camera and edited.

tool A program specifically designed to produce a particular effect on-screen, activated by choosing an icon and using it as the cursor. In image-editing, many tools are the equivalents of traditional graphic ones, such as a paintbrush, pencil, or airbrush.

toolbar An area of the screen used to provide immediate access to the most frequently used tools, settings, and commands.

USM (Unsharp Mask) A sharpening technique achieved by combining a slightly blurred negative version of an image with its original positive.

vector graphic A computer image in which the elements are stored as mathematically defined lines, curves, fills, and colours. Vector graphics can be scaled up or scaled down at will without any effect on resolution.

white balance A digital camera control used to balance exposure and colour settings for artificial lighting types with a colour temperature different from daylight.

zoom A camera lens with an adjustable focal length, giving, in effect, a range of lenses in one. Drawbacks include a smaller maximum aperture and increased distortion over a prime lens (one with a fixed focal length).

Index

Acknowledgments

To my clients and subjects, thank you for asking me to share your special days – it has been an honor. To parents and family, thank you for encouraging me to do what I love. To my teachers and colleagues, thank you for sharing your wisdom with me – I learned more from you than you can know, and now it's my turn to teach. To the Ilex Press, thank you for guiding me through the birth of this book, especially to Adam Juniper for his keen direction and editing skills.

Finally, to my wife and best friend, Nicki, thank you for your love and faith in me. I would not be here without you. All my love.

Useful Addresses

Adobe (Photoshop, Illustrator)
www.adobe.com
Agfa www.agfa.com
Alien Skin (Photoshop Plug-ins)
www.alienskin.com
Apple Computer www.apple.com
Association of Photographers (UK)
www.the-aop.org
British Journal of Photography
www.bjphoto.co.uk
Camera bits www.camerabits.com
Canon www.canon.com
Corel www.corel.com
Digital camera information
www.photo.askey.net
Digital wedding forum
www.digitalweddingforum.com
Epson www.epson.co.uk www.epson.com
Extensis www.extensis.com
Formac www.formac.com
Fujifilm www.fujifilm.com
Hasselblad www.hasselblad.se
Hewlett-Packard www.hp.com
iView www.iview-multimedia.com
Kingston (memory) www.kingston.com
Kodak www.kodak.com
LaCie www.lacie.com
Lecia www.lecia-camera.com
Lexmark www.lexmark.co.uk
Linotype www.linotype.org
Luminos www.luminos.com

Microsoft www.microsoft.com
Minolta www.minolta.com
www.minoltausa.com
Nikon www.nikon.com
Nixvue www.nixvue.com
Olympus
www.olympus.co.uk
www.olympusamerica.com
Paintshop Pro www.jasc.com
Pantone www.pantone.com
Philips www.philips.com
Photographic information site
www.ephotozine.com
Photoshop tutorial sites
www.planetphotoshop.com
www.ultimate-photoshop.com
Qimage Pro
www.ddisoftware.com/qimage/
Ricoh www.ricoh-europe.com
Rob Galbraith www.robgalbraith.com
Samsung www.samsung.com
Sanyo www.sanyo.co.jp
Shutterfly (digital prints via the Web)
www.shutterfly.com
Sony www.sony.com
Sun Microsystems www.sun.com
Symantec www.symantec.com
Umax www.umax.com
Wacom (graphics tablets)
www.wacom.com